PAPERCUTTING

PAPERCUTTING

Reviving a Jewish Folk Art

AMY GOLDENBERG

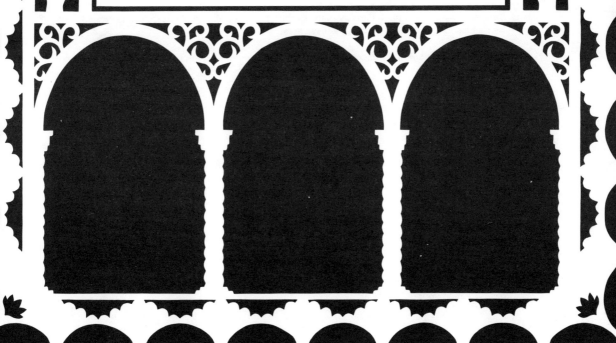

JASON ARONSON INC.
Northvale, New Jersey
London

This book was set in 11 pt. Korinna by Alpha Graphics of Pittsfield, New Hampshire, and printed by Haddon Craftsmen in Scranton, Pennsylvania.

Library of Congress Cataloging-in-Publication Data
Goldenberg, Amy.
 Papercutting : reviving a Jewish folk art / by Amy Goldenberg.
 p. cm.
 ISBN 0-87668-593-9
 1. Paper work. 2. Folk art, Jewish. I. Title.
 TT870.G55 1994
736'.98—dc20 93-29374

Manufactured in the United States of America. Jason Aronson Inc. offers books and cassettes. For information and catalog write to Jason Aronson Inc., 230 Livingston Street, Northvale, New Jersey 07647.

To my grandparents
Mac Bell ז״ל
and
Elaine Bell ז״ל
May their memories be for a blessing.
They are a part of my history.

CONTENTS

ACKNOWLEDGMENTS

The idea for writing this book was ignited at the 1989 Coalition for the Advancement of Jewish Education conference in Seattle, Washington. The papercutting, however, began a decade earlier. During my last semester as an art major at California State University, Northridge, I had an assignment to create something out of paper. Working mainly in metal arts, but investigating other media as well, I had begun exploring Jewish themes in my work. Adele Lander, then program director of CSUN Hillel, suggested I try doing a papercut. Having worked mainly in three-dimensional media, I knew practically nothing of paper or paper quality. Still, the little information I could find about papercutting was enough to get started. That first simple papercut, cut with manicuring scissors and made of construction paper(!), hangs in the bedroom of Adele's daughter, Rachel. It is yellowed and brittle, but for me it holds much significance. After that papercut, I was hooked. I haven't picked up a jeweler's saw since I've been out of school, but I have yet to put down my X-Acto knife.

There are several people who have been immensely helpful during the course of researching and writing this book. I could not have begun or finished this project without them. I owe them all a great deal of thanks.

Adele Lander Burke, Cecily Kaplan, and my sister, Stacy Anne Goldenberg, read all chapters of the manuscript in their many stages. Their comments and suggestions were always insightful and helpful. Stacy, an incredibly talented artist in various media, was of particular help with the instructional chapters. We had many long conversations throughout my progress. Though I always felt confident that I was covering all the bases, she, nonetheless, would inevitably ask, "Did you remember to talk about such-and-such?" Sure enough, she was referring to some topic I had overlooked.

During the initial stages of writing, David Myers was of great assistance, from helping me develop the original outline to reading the

first drafts of the history chapter. He also read the few Hebrew sources I found and summarized them for me. We had many lunchtime discussions about writing. When I kept thinking about the end result, he forced me to focus on starting.

Mark Stine read the instructional chapters with me over and over. His attention to detail and his knowledge of designing were very appreciated. He had, long before, introduced me to all the fun drafting tools that he uses in designing his stained glass. Using them in my own work has made the designing process much easier and more accurate.

Rick Burke helped me set up my computer for writing and allowed me access to his laser printer for printing the manuscript.

Craig Hillis, computer-graphics artist extraordinaire, used his computer to fill in the shading on the patterns and made them camera ready. He also prepared sample layouts of the book jacket and title page. His help was invaluable.

Char Krasnoff helped me prepare the actual camera-ready pasteups for the title page and book jacket. Since I've had minimal pasteup experience, I am very grateful for her assistance. She produced pasteups I could be proud of.

Francine Carroll created the Hebrew alphabet located on page 55. I appreciate her help.

I wanted to make sure that others could cut the patterns I designed, so I had friends and family members create the samples that are illustrated within. Some are artists, others are not. Children, teenagers, and grown-ups, their ages ranged from eight to over forty. In alphabetical order, they are: Jeremy Alk, Micah Alk, Rachel Burke, Carla Chadwick, Rachel Fliener, Anne Shorr Ne'eman, Marcia Plumb, Michael Shire, and Mark Stine. Thanks all.

Pam Davis of the Canvas Peddler in North Hollywood, California, answered several questions regarding framing. I always enjoy going to that store for my framing needs.

Suzanne Kester of the Skirball Museum in Los Angeles, California, was most kind in allowing me access to several slides from their collection that are used in this book.

Joan Benedetti, museum librarian of the Craft and Folk Art Museum in Los Angeles assisted me in obtaining addresses of folk art museums around the country. The responses to my survey from museums around the world are also appreciated.

When I first approached Arthur Kurzweil of Jason Aronson Inc.

with my idea for this book at the CAJE conference, he knew nothing about papercutting. Nevertheless, he proceeded to ask me numerous probing questions that helped me to focus and expand my idea. That first conversation, as well as the meeting we had several months later in Los Angeles, have remained highlights of this entire project.

The genuine interest and enthusiasm from a wonderfully supportive circle of friends and from my family has been a constant source of encouragement. During bike rides and over coffee, at dinner and at lunch, over the phone long distance and in person, I have discussed my progress during the course of this project with caring people who offered unique perspectives and asked questions that kept me focused and striving for clarity of thought. To name a few: Camille Angel, Carla Chadwick, Laurie Friedman, David Goldenberg, Stacy Anne Goldenberg, Cecily Kaplan, Char Krasnoff, Anne Shorr Ne'eman, Mark Stine, and Kathy Marin Wohlfeld. Their questions and comments and their faith in my ability have been motivating and inspiring. I thank them all.

Growing up in a home with artistic parents and exposed to art our whole lives certainly influenced the creative paths David, Stacy, and I chose to take. Being surrounded by filled bookshelves at home and weekly visits to the public library throughout my childhood instilled in me a joy of books and reading. It was inevitable, I suppose, that I would end up writing a book about art. I have had the encouragement, support, and love of my parents, Donald Goldenberg and June Goldenberg, throughout the writing of this book, as well as in every other endeavor before or since. I know it has given them such *nachas* to tell everyone they know, "My daughter is writing a book."

INTRODUCTION

The talmudic precept of *hiddur mitzvah*, to beautify the observance of ritual commandments, has been a guiding force behind the creation of works of art by Jews throughout history. Because religious ritual plays such an important role in Jewish life, it follows that the objects connected to them become important as well. Creating objects used in holiday and life-cycle rituals and ceremonies allows for an artistic expression of one's devotion to Judaism in the way that study and the observance of the commandments provides an intellectual one. This precept of *hiddur mitzvah* not only gives Jews the opportunity to create works of art, but it also commands them to do so.

On the other hand, the Second Commandment clearly states the prohibition against graven images or representational art meant for the purposes of idolatry. "You shall not make for yourself a sculptured image, or any likeness of what is in the heavens above, or on the earth below, or in the waters under the earth" (Exodus 20:4). This commandment has, on occasion, been the cause of a misunderstanding regarding Judaism and art. It has been thought that this commandment has excluded art of any kind among Jews.[1] While it is true that graven images are forbidden, the much wider and diverse world of art involving the creation of ritual objects, as well as decorative art that celebrates and honors different aspects of Judaism, has always been a part of Jewish life.

Objects such as the *Kiddush* cup, *challah* cover, or the *chanukiah* have a direct practical use in the observance of a ritual or holiday. Others, while being more decorative, still have a direct use in the celebration of a particular event or holiday. *Sukkah* decorations and Simchat Torah flags, for example, enhance the celebration of the holiday. A decorated *chuppah* adds visual beauty to a wedding ceremony. Objects in a synagogue, such as the *ner tamid* (eternal light), the *parochet* (ark curtain), and Torah shield and *rimonim* (finials) on the Torah all honor and demonstrate the importance and holiness of this sacred place.

Still other objects, not associated with a particular celebration, reflect the customs and traditions of the people. The *mezuzah*, probably the most publicly displayed symbol in Judaism, is a perfect example. The beautifully crafted cases holding the prayer inside reflect the importance of the religious custom of hanging the *mezuzah* on the doorposts of the home. The *mizrah*, a decorated wall hanging for the east wall as a reminder of the direction toward Jerusalem, is another example of an expression of religious culture through art. Whether used to enhance ritual and ceremony in the synagogue and home or to express cultural ties, these works of art become an integral part of the lives of the people who use them. These creations are examples of folk art.

In its traditional sense, folk art is created by people for their own use or within their own community. It is created out of a desire to reflect community and individual values and needs, not for a government or an elitist point of view. It is not something you would find in the palaces of royalty. Rather, it is found in the homes of the "folk." I sometimes think of it as "art for the people and by the people." Creating, using, and displaying a work of folk art links people to their community and to the history and traditions of their past. For all these reasons, folk art encompasses the ceremonial objects of Jewish life.

Papercutting is an ideal example of folk art. From its beginning it was an art form of the common person, its skills passed from generation to generation. Interestingly, it is a folk art found in almost every culture in the world. The motifs, styles, and uses of papercuts, in addition to the techniques of cutting, vary among different cultures, each reflecting the history, traditions, and surroundings of that particular place and people. Among Jews, papercutting became another medium in which to follow the precept of *hiddur mitzvah*, to enhance and beautify the rituals and ceremonies that are a part of our culture and religious traditions.

The intent of this book is to introduce papercutting as a means of artistic expression to Jewish life. Any creative outlet that enables us to look at our customs and traditions with a fresh eye can enrich our lives and those around us, and it can renew our desire to carry the traditions into the future.

CHAPTER 1

THE ORIGINS OF JEWISH PAPERCUTTING

One of the most human of impulses is the desire to leave evidence of our lives for future generations. From the earliest cave drawings to the most sophisticated computer disk, written and oral records tell a story about the past and the people who lived it. Scholars spend their lives studying these stories, and from their discoveries, we learn about ourselves by seeing where we came from and how we got to where we are.

An important event in facilitating the written recording of human history was the invention of paper. Cai Lun, who worked in the emperor's court in China, is credited with having invented paper around 100 C.E.[1] What he actually did was refine and perfect a product that had been in use in China for some time. With his refinement, paper became a much more usable product. In fact, very little has changed since then in the basic manufacture of paper.

The invention of paper had consequences not only for the impulse to record, but for another human impulse: the desire to beautify one's self and one's surroundings. Embellishing objects used in daily life, adding flourishes to clothing, and decorating homes during special times of the year are ways in which people make their surroundings more aesthetically pleasing. Following its invention, paper became a medium with which to beautify. Art forms using paper developed, and one of the most creative of them was papercutting.

Although the exact date is unknown, papercutting started in China soon after the invention of paper.[2] Its origins lay not in the royalty of China, but rather among the common people. Hence, it can be described as a genuine folk art. Moreover, it was an art form created by and for women. Women made papercuts to decorate their hair, to use as window and home decorations during holidays and weddings, and to give as wedding gifts to their husbands. Because of its frequent use in decorating windows, papercuts in China were often called "window flowers." Papercuts were also used as patterns for embroidering on clothing. The papercut was placed on top of the fabric and the embroidery was sewn right over, covering it completely. Later, papercuts were used as stencils for ceramic glazing. Women believed their skill at papercutting was a reflection of the character and inner beauty of their gender. As such, it was a tradition and skill deemed essential to pass on to their daughters.

The invention of paper and its various uses were kept a secret within China for several hundred years. Things began to change around the fifth century C.E. when commercial routes to China opened up, with merchants traveling in and out of the Far East. It was along these routes that paper began to spread to other parts of the world, first moving to Korea and Japan,[3] then India, and eventually farther and farther west. When first practiced outside of China, papercutting was used for the same decorative purposes it had been within China. Closely related was the development of the shadow theater, whose roots also extended to China.[4] Using techniques similar to the ones used for papercutting, shadow-theater puppets were cut from paper or leather.

Little information exists about papercutting until the fifteenth century, when it found a more commercial use in Persia and surrounding areas through the highly developed art form of bookbinding.[5] Leather bindings were cut with intricate designs and filled with filigree paper. Persian bookbinders moving into Turkish cities brought this art form to the Ottoman Empire during the sixteenth century.[6] Throughout the empire, papercutting was put to new uses in book production: in combination with calligraphy, letters were cut out in a decorative fashion, and in manuscript illumination entire pages were illustrated with papercuts. Papercutting flourished within Islamic countries through these book arts.

It is difficult to pinpoint exactly when and where the first Jewish papercuts were created. While early examples of Jewish papercuts do

not exist, there is written evidence of their presence in various Jewish communities. A text made up of cut-out letters dates from the fourteenth century.[7] Written by Rabbi Shem Tov ben Isaac Ardutiel of Sori (Spain), it is appropriately entitled *The War of the Pen with Scissors*. This particular text combined two popular activities of the time, one literary, the other artistic. The literary activity was an actual debate, a common way for scholars to display argumentative skills by discussing two opposites. The latter activity was the art of cutting out letters, which has been discussed in reference to book arts within Islamic countries. Included in this pen-versus-scissors debate, the author refers to the time his inkwell froze and he was forced to write by cutting out letters.

Further evidence of Jewish papercutting appears in a letter of 1647 from Princess Charlotte of Hessen to her brother. In it she relates that a converted Jew by the name of Goldschmidt-Friedstadt is teaching her to cut paper.[8] In addition, a Dutch manuscript from the seventeenth century mentions a Sephardic Jew who was adept at papercutting.[9]

Since papercutting outside of China developed first in the Ottoman Empire and other Islamic countries, the likelihood is that Jews living in those regions discovered papercutting before Jews in Central and Eastern Europe. The expulsion of Jews from Spain in 1492 brought large numbers of them to the Ottoman Empire at the end of the fifteenth century and well into the sixteenth century. While Jews retained their religious and cultural lifestyles and traditions upon settling there, they interacted with the non-Jewish community in business and commercial matters. Moreover, they contributed to the economic growth and development of the Ottoman Empire. Jews most likely became interested in papercutting as a result of their interaction with the larger society around them.[10] Even so, such evidence as the previously mentioned fourteenth-century text from Spain demonstrates that they brought some knowledge of the art form with them.

Although there is evidence of a papercutting guild in Istanbul as early as 1582, no examples exist of Ottoman Jewish papercuts from earlier than the latter part of the nineteenth century. Nonetheless, the fineness of detail and skill that is found among those existing Jewish papercuts suggests that the art form had been refined over centuries.

It is well known that the interaction between Jews in the Ottoman Empire and Jews in Europe was quite extensive, especially in the realm of commerce. The art of papercutting likely made its way into Holland and Italy along the commercial routes covered by the

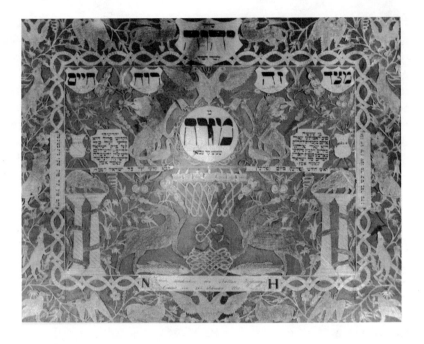

Mizrach, Odessa, Russia, 1890.
Nathan Hoffman, paper cutout,
 water color.
39.39
From the collection of the
 Hebrew Union College Skirball
 Museum.
Marvin Rand, photographer.

Sephardic Jewish merchants. From these centers, papercutting was likely transmitted to Eastern European Jewish communities. As discussed previously, the evidence suggests that Jewish papercutting existed in Europe as early as the seventeenth century. It reached its peak of popularity in the mid-nineteenth to early twentieth centuries in Eastern Europe. There, it was popular among *yeshivah* and *cheder* students and teachers who enjoyed papercutting in their spare time.[11]

Quite unlike the Chinese tradition, papercutting within the various Jewish communities was an art form created by men, not women. The types of papercuts that were popular within the Jewish community utilized religious texts and subjects, areas that were traditionally off limits to women. It is probably for this reason that papercutting was unavailable to women as well. Happily, this is not the case in modern times.

While papercutting had a more commercial use in book arts among non-Jews in Islamic countries, in the Jewish communities it had a more cultural purpose. Used for a variety of occasions, they reflect customs and lifestyles associated with holidays and family life.[12] There is a shared set of themes and uses in Jewish papercuts from the various communities in which the art form was found. What differs

is the artistic styles, each reflecting the influence of the non-Jewish surroundings of the particular community.

The most popular type of papercut in Eastern Europe was the *mizrah*.[13] These are decorations for the home hung on the east wall as a reminder of the direction toward Jerusalem in which one faces while praying. In the central part of these cuts are the Hebrew letters spelling *mizrah* (*mem, zayin, raysh, chet*), מזרח. Literally meaning "east," *mizrah* is an acronym for "*mezah zeh ruah hayyim*," "From this direction comes the spirit of life." Often, the four Hebrew words were put in the four corners of the papercut. They were large and detailed and brightly painted with watercolor.

Another popular papercut, the *shiviti*, is a variation of the *mizrah*. It contains the Hebrew letters יהוה (*yud, hay, vav, hay*), in the central part of the papercut. The *shiviti* includes verses from the Holy Scriptures, the most common being Psalm 16:8: "*Shiviti Adonai le-negdi tamid*" ("I have set the Lord always before me"). Many times kabbalistic inscriptions and prayers were also included in these papercuts as well. These verses were often written on the arms of the *menorah*, a popular symbol seen in these papercuts. The *menorah*'s frequent use in *shiviti* papercuts, often repeated many times in one cut, led

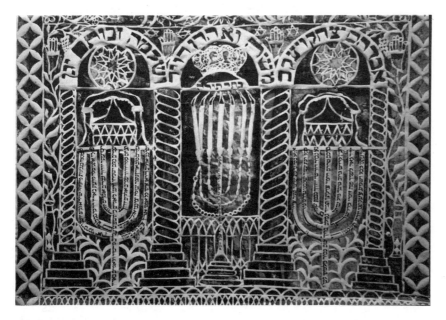

Notice the images of the *hamsa* along the top of this papercut. Menorah Plaque (papercut mounted on colored metal), North Africa, early 19th century. Musée d'Art Juif du Paris, Paris, France.

Shivitim for Sukkot are sometimes referred to as *Ushpizin*. Translated, *Ushpizin* means "symbolic guests," and it is a special greeting said each night of Sukkot inviting seven mystical guests into the *sukkah*. The traditional greeting invites seven men from the Bible: Abraham, Isaac, Jacob, Joseph, Moses, Aaron, and David. Each night the greeting is directed to one of the guests, who is greeted by name and invited along with the other guests who are also named. The greeting, in Aramaic rather than Hebrew, is traditionally included in these papercuts, which are hung on the walls of the *sukkah*.

It has become a common practice among egalitarian circles, during Sukkot, to include a greeting for seven women as well. This *shiviti*, in addition to welcoming the men, also welcomes Sarah, Rebecca, Rachel, Leah, Miriam, Hannah, and Deborah.
Artist: Amy Goldenberg. 1990, artist's collection.

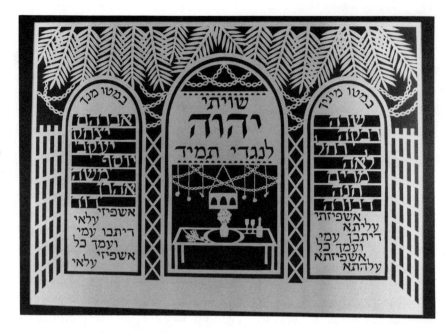

them to be called "*menorah* plaques" in some communities. Although the *shiviti* could be found in Eastern Europe, it was a more common form of papercut in the Ottoman Empire and other parts of the Middle East. In the Ottoman Empire, *shiviti* papercuts were multilayered, created in a collage technique, using several different colors of paper and sometimes a shiny foil paper.[14] Two artists known to have created these types of papercuts within the Ottoman Empire were Hayyim Yauda Algranti and David Algranti in the late nineteenth to early twentieth centuries. In Eastern Europe, the *shiviti* was similar in style to the *mizrah*, although it was more often hung in the synagogue than in the home.

In addition to the *menorah*, the *mizrah* and *shiviti* papercuts contained a wide array of symbols, many of them seen in other branches of Jewish art, as well as in other types of papercuts.[15] Among these symbols were a Torah with crown often held up by a pair of lions, mythological beasts, plant life including trees to symbolize the Tree of Life and flowers, architectural forms such as pillars and arches, and the animals reflected in the verse from *Pirke Avot* 5:23, "Be as strong as the leopard, light as the eagle, swift as the deer, and brave as the lion to do the work of the Lord." Another symbol used in papercuts of

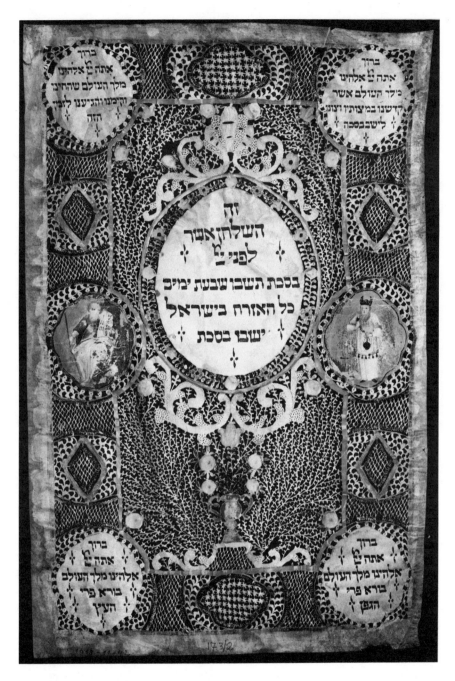

Sukkah Decoration (papercut).
Germany, 18th century.
Collection Israel Museum,
	Jerusalem.
Photo credit: copyright © The
	Israel Museum.

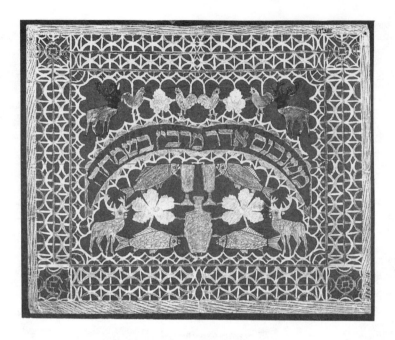

Adar Poster (papercut).
Germany or Carpathian Mountain
region, late 19th century.
Jüdisches Museum der Schweiz.
Basel, Switzerland.

the Ottoman Empire and parts of the Middle East, but unknown in Europe, was the *hamsa*, which resembles a hand. This mystical symbol is intended to bring good luck. To guard against the evil eye, sometimes the shape of an eye is seen within the *hamsa*.

While the *mizrah* and *shiviti* had year-round use, other forms of papercutting were connected with holiday celebrations. In Eastern Europe, particularly in the Galicia region of Poland, one popular form of papercut created for the holiday of Shavuot was the *shevuoslekh*. Rectangular in shape, they were cut out of white paper and left unpainted. Taped to the windows of the home as decorations for the holiday, they were a common sight seen from the street. This public display made these Shavuot papercuts unique in that they were seen by the general community, rather than the more private display of other papercuts seen only by the Jewish community. Sometimes the Hebrew words "*Chag Ha-Shavuot Ha-Zeh*" ("this Shavuot festival") were cut out in the papercut along with the traditional symbols of flowers, *menorot*, birds and other animals. Some have been found to include soldiers. A variation of these Shavuot papercuts were round cuts in a rose or flowerlike shape, called *royselekh*, for the Yiddish word for rose.

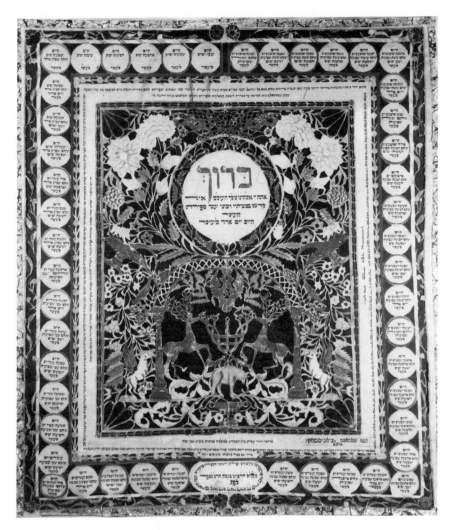

Omer Calendar (papercut).
Poland, 1866.
Collection Israel Museum,
 Jerusalem.
Photo credit: copyright © The
 Israel Museum.

In the Ottoman Empire, artist Yosef Abulafia, in the late nineteenth century, created three-dimensional *sukkah* decorations by folding four sheets of different colored paper into a booklet. After cutting through the eight layers of paper, the booklet was sewn together at the fold, and then hung from the *sukkah* roof.[16] *Shivitim* with the special *Ushpizin* prayer included in the design were created to decorate the walls of the *sukkah*. *Ushpizin* means "symbolic guests." The prayer is in Aramaic, not Hebrew, and it invites a different honorary guest into the *sukkah* each night of Sukkot.[17] For a further explanation along with an example see page 6. These were popular in both Eastern Europe and the Ottoman Empire.

Simchat Torah flags, *Omer* calendars, and Purim posters for the synagogue were other forms that papercuts took in enhancing holiday celebrations and rituals. In the same vein, two *megillot* Esther, read during the holiday of Purim, with papercut borders, one from seventeenth-century Italy, the other from nineteenth-century Persia, have survived to this day. Lanterns with papercut panels were popular wedding decorations. Papercut lanterns were also made to commemorate the *yartzeits* of famous rabbis.

Yet another use of papercutting was in *ketubot* (marriage contracts). Several examples of papercut *ketubot*, decorated with multilayered collages, were found in Turkish cities. In Italy, illuminated *ketubot* from the sixteenth to eighteenth centuries, made on parchment rather than on paper, included intricate papercut designs. Having been influenced by the lavish beauty of non-Jewish Italian art, these illuminated and cut-out *ketubot* became a very sophisticated art form by the seventeenth century and were created by highly skilled artisans. As the cost grew, it became a luxury most people could not afford. A law was passed in 1776 in the town of Ancona, Italy, prohibiting people from spending more than forty *paoli* for an illuminated *ketubah*.[18]

In addition to their celebratory function, papercuts in Eastern Europe were used as amulets to protect mothers and newborn children. These cuts were placed on the four walls of the birth room and were called *kimpetbrivelekh* (*kimpet* from the old Yiddish-German meaning "childbed" and *brivel* meaning "letter") or *Shir-ha-Maaloskekh*, from the opening words of Psalm 120: "*Shir ha-maalot el Adonai batsarata li karati*" ("Song of Ascents. In my distress I called to the Lord"), which was always found in the center of the papercut.

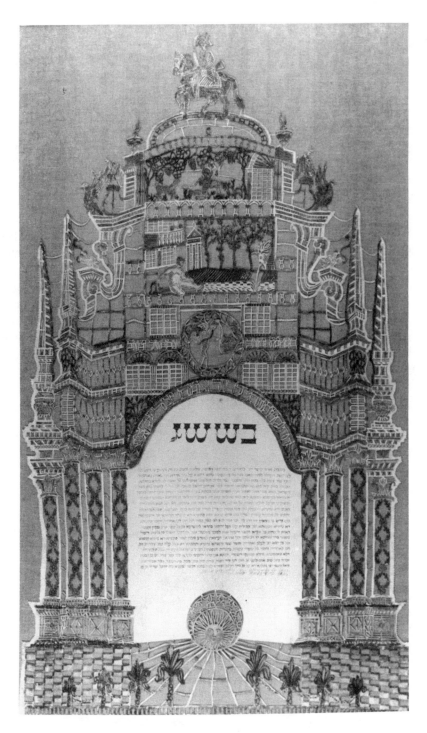

Ketubah (parchment, paint, ink).
Fiorenzuola, Italy, 1832.
34.110
From the collection of the
 Hebrew Union College Skirball
 Museum,
Los Angeles, California.
Leo Carter, photographer.

When Eastern European Jews began moving to America, during the second half of the nineteenth century and into the twentieth century, they brought their folk art traditions with them. This new wave of Jewish immigrants had a firmly rooted tradition of folk art, unlike the Jews who had come to America before them.[19] Up until that time there had been very little folk art in America that could be labeled "Jewish." While earning a living in various trades, these artists continued to create folk art in their spare time, as they had in Europe. Jewish art in America, not only papercuts, but all media, was created by these artists for synagogues and homes, for celebrations and rituals. Artists began to use symbols representing their new home in America, as well as the traditional symbols and themes seen in the past. Papercut artist Phillip Cohen created a *shiviti* papercut in 1861 that includes American flags.[20] A picture of this papercut is shown on page 13.

Other well-known papercut artists from this era included Baruch Zvi Ring (1870–1927) and Mordechai Reicher (1865–1927). Baruch Zvi Ring's earliest known papercut was done at age ten in Lithuania. After arriving in America in 1902, he earned his living as a Hebrew teacher and *sofer*. Yet, he continued to create monumental papercuts for different synagogues and Jewish organizations. His daughter Katie continued the tradition by creating a papercut memorial plaque, sometime after 1949, although her work was neither as grand nor as detailed as was her father's work.[21]

Mordechai Reicher came to America from the Ukraine in 1910. Known as a talmudic scholar, it is likely that he had learned papercutting as a hobby, which was popular among *yeshivah* students of his time. After an illness in 1918, which left him unable to continue his trade as a peddler, he devoted his time to teaching Talmud and creating papercuts.[22] His papercuts were brightly decorated with watercolor and included many verses from Hebrew texts. One papercut, done in 1922, included an American flag.

As Jews strived to assimilate into American society, interest in the creation and preservation of folk art tapered off after the first few decades of the twentieth century. It wasn't until the second half of the twentieth century that a renewed interest began to flourish. It is of particular importance that the folk art traditions of our past are not forgotten because so much of what had been created in Europe was destroyed during the Holocaust. Not only are contemporary artists creating new works, but many long-lost works of art have been found

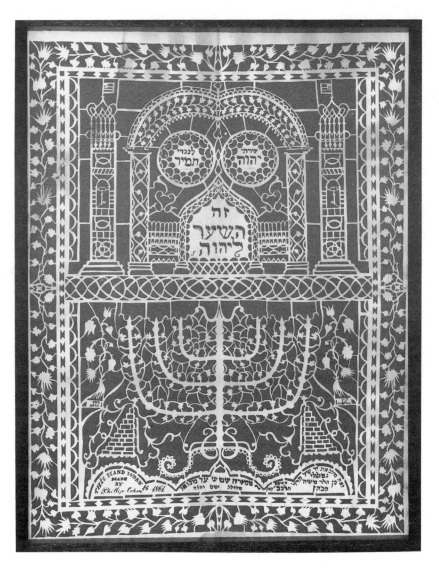

Shiviti (papercut).
Artist: Phillip Cohen.
United States, 1861.
39.17
From the collection of the
 Hebrew Union College Skirball
 Museum,
Marvin Rand, photographer.

by the families of early twentieth-century artists. Preserving papercuts is especially difficult because the medium is very fragile, unlike other artwork of metal, fabric, or wood.

Just as the artists coming from Europe to America combined the symbols and style of the old with symbols of their new home, contemporary papercut artists combine the traditions of the past with new styles and techniques. The variety and accessibility of higher quality papers and the development of new, easier-to-handle tools than those of the past have given the artists of today the opportunity to create papercuts that blend the old traditions with new ideas in design, while allowing their works to be preserved for many years to come.

Knowing our history enables us to carry its traditions into the future. Each individual in every generation adds new perspectives and experiences to create an even grander tradition for the future. If learning the history of Jewish papercutting has sparked your interest to continue the tradition, then you too can add a part of yourself to its continuing history.

CHAPTER 2

INSTRUCTIONS ON HOW TO BEGIN PAPERCUTTING

This chapter focuses on papercutting for the beginner. Reading and utilizing the patterns that follow will familiarize you with the techniques, materials, and tools involved to create a papercut with minimal investment. These instructions can be adapted to an educational setting for teaching culture and history through the folk art of papercutting or as a family project on a rainy day or in preparing for a holiday celebration. People who intend to explore the art form further should begin here by establishing a basic knowledge of papercutting before moving ahead. In the chapter following the patterns, there is a more detailed explanation of papercutting involving more of an investment of time and money than that presented here.

The patterns in this book are of varying levels of difficulty and can be used for a variety of occasions that are traditional to Jewish papercutting. The description accompanying each pattern will explain design motifs and offer suggestions that will assist you in execution. The descriptions will also include suggestions on ways in which you can add your own touches such as adding more detail to some of the simpler designs. The pictures of the completed patterns shown on the facing pages will give you some idea as to how they will look without any personal touches added.

OBTAINING TOOLS AND MATERIALS

Before moving on to describe the patterns, let's go over the tools and materials needed to get started. One of the nicest aspects of papercutting is that it is a very "portable" art form. You can take it with you anywhere. The tools and materials are not bulky and are easily found in a variety of stores.

The first item you need to decide on is the cutting tool. The two options are a pair of scissors or a utility knife. If using scissors, the best choice is a very small pair of scissors, such as manicuring or embroidery scissors. There are other small size scissors on the market that are fairly easy to use when cutting simple designs and are ideal for children to use. Look in artist's supply and stationery stores for what is available.

The second option, a utility knife, such as the X-Acto knife, enables you to cut out very detailed designs that cannot easily be cut with scissors. The sharp point of the #11 blade makes it ideally suited for papercutting. Utility knives can be purchased at artist's supply and stationery stores. The blades are disposable, and packages of extra blades can be purchased in the same places. If you plan on doing a lot of papercutting, you might consider buying blades in bulk—packages of 100 blades—for a good buy. You will be amazed at how quickly you go through them. Changing blades frequently, to assure sharpness, will make cutting easier and keep the cut lines free from tears and jagged edges. The knife is held like a pencil when cutting. Wrapping the metal handle with a piece of gauze where your fingers rest will keep your fingers from getting sore. X-Acto carries a type of knife handle called the Gripster. Rather than metal, the handle is made of rubber and keeps the fingers from getting sore.

One important note: It is recommended that children under twelve not use utility knives when doing papercutting. From the age of eight, most children can use scissors with enough control to be able to do a simple papercut.

One item you will need when using a knife, as opposed to using scissors, is a cutting surface. It is always possible to cut out a design by placing the paper on top of an old magazine or a piece of posterboard, tag board, or shirt cardboard, but the ideal cutting surface, which will prove a worthwhile investment, is a self-healing mat cutting board. This kind of board can be purchased at artist's supply stores and come in a variety of sizes. Using it makes cutting easier

and always gives a cleaner cut to the lines. A cutting board will also keep the blades from dulling so quickly. The more you cut, the more you will develop a technique and learn ways to get clean, sharp, jagged-free lines.

MAKING PATTERNS

To use a pattern from this book you will need to copy it either by tracing it onto another sheet of paper or by using a photocopy machine. It is recommended that you use a lightweight bond paper, such as the type used in photocopy machines, whether you trace the design or copy it by machine. The dotted lines show where to fold the paper before you begin cutting. Solid lines are cutting lines. The shaded areas indicate all sections that will be cut away.

To trace a pattern from the book, place a clean sheet of unfolded paper over the pattern. Use a soft pencil (a #2 lead pencil will work best) and trace over every solid line including the outside border. You may want to trace over the dotted lines as well if that will make it easier to fold the paper in the right place when you are ready to begin cutting.

When using a photocopy machine, the pattern can be reproduced in the size shown in the book, or, if your copy machine does enlargements, any pattern can be enlarged. Use 8½" × 11" paper if the pattern will not be enlarged. Enlarging the patterns by 33 percent (the machine should be set at 133 percent) will produce an 8½" × 11" size pattern, but it is suggested that when enlarging, you copy onto 11" × 17" paper so that it won't be so difficult to get the pattern centered on the paper. This is the largest size paper that can be used in photocopy machines. These patterns can be enlarged by as much as 65 percent (set the machine to 165 percent) and will still fit on 11" × 17" paper. Enlarging the simple patterns will make it easier for children to cut them, while those attempting the more intricate patterns may find it easier to cut out the very small spaces by enlarging them by 33 percent. These patterns were actually designed in an 8½" x 11" format.

To photocopy, the book should be placed on the machine so that the pattern will come out fairly centered on the paper, although it does not have to be exact. The more a pattern is enlarged, the more carefully it will have to be centered. If it is too far off center, when the pattern is folded along the dotted line, there may not be enough paper on the

blank half to meet the edge of the printed half. When making the copy, it is important that the page with the pattern is flat against the glass of the machine to avoid distortion of the copy. To copy, carefully lay the book face down and gently press down on the book. If you are making multiple copies, after you have made one good copy using the book, you might find it easier to then place that copy on the machine to reproduce more. If you have enlarged the pattern from the book and then proceed to make multiple copies from that enlargement, be sure to reset the machine back to normal copy (100 percent). Otherwise, the further copies will come out even larger.

It is important to note that the patterns are drawn backwards. All pencil lines are drawn on the *back* of the paper to be cut. That way the front stays clean. Symmetrical designs look the same from the front or the back, but you will notice immediately that the Hebrew letters in designs are backwards. After cutting, when the paper is turned over to the front, the letters will appear correctly.

When you are ready to get started papercutting, you can choose a pattern based either on the degree of difficulty or the occasion.

CUTTING

Some of the patterns are rectangular in shape with a distinct border. If you fold the paper exactly on the dotted line before beginning the papercut, it should not matter whether you cut away the excess paper surrounding the outside line first or last. This outside line should, however, be cut with the paper unfolded. For nonrectangular patterns, it will probably be most helpful to cut off the excess paper surrounding the outer rectangular outline first, with the paper unfolded. Then, after folding and completing the papercut, cut along the outside border line of that particular pattern.

COLORING

After the papercut is completed, but before you paste it to the background paper, you may choose to add color to the cut-out design. This was a common practice with the papercut *mizrahim* and *shivitim* of Eastern Europe. Watercolor paints will look nice and bright. Children may prefer to use crayons, markers, or colored pencils.

If you add a great deal of color to any design, it might look nice afterwards to use a white background paper. The important thing is to see the lines of the papercut. When adding color to the papercut, either with paints, crayons, or markers, put a piece of paper underneath the cut to protect any table surface.

Remember, adding color is only an option. Some people like the simple purity of a white papercut against a contrasting background.

GLUING

Once the design is cut out, you will then adhere it to a background paper. Rubber cement has always been a favorite glue to use with paper. With rubber cement, the paper will not wrinkle, and after it dries, any excess that oozed out of the sides can be easily rubbed off with your fingers. Rubber cement should always be used in a well-ventilated area. It is not a good idea to allow children to use rubber cement unsupervised. The fumes are strong and potentially dangerous. There are other adhesive products on the market that will work just as well and are better suited for children. Library paste is one suggestion and can be found in artist's supply and stationery stores, along with other adhesive products you can check. Never use white glue when gluing paper; it causes wrinkling. The best way to glue is to put it just along the edge of the papercut and in a few strategic spots in the middle.

When you choose a background paper, you will want to use a contrasting color. Construction paper comes in assorted colors and is inexpensive. If you want to use better quality paper, check the paper selection at an artist's supply store. There are several brands of fairly inexpensive paper sold in large sheets that can be cut to the desired size. These papers come in a variety of colors and are brighter and cleaner than construction paper.

CHAPTER 3

THE PATTERNS

LIONS AND TABLETS

This simple pattern can be cut out with scissors and is ideal for children who want to try their hand at papercutting. It is also a good pattern for other beginners to papercutting who may not feel ready to attempt a more complicated design. Children will have an easier time cutting this pattern if it is enlarged by at least 33 percent.

The Hebrew letters can be cut out with a utility knife, or children may want to draw, color, or paint the letters on the front of the design after the cutting is completed. By holding the pattern against a window, with the back against the glass, the letters can be seen easily through the paper. Trace over the Hebrew letters with a pencil so that they show on the front of the pattern. This will make it easier for children to color in the letters. If you are cutting out the letters, remember that the paper needs to be unfolded first.

Personal touches can be added to this pattern by adding lines to the mane of the lion or by adding small shapes surrounding the Hebrew letters in the tablets. First draw the additions with a pencil on the back of the pattern, then cut them with a utility knife.

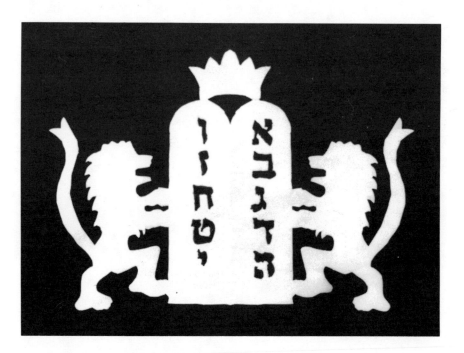

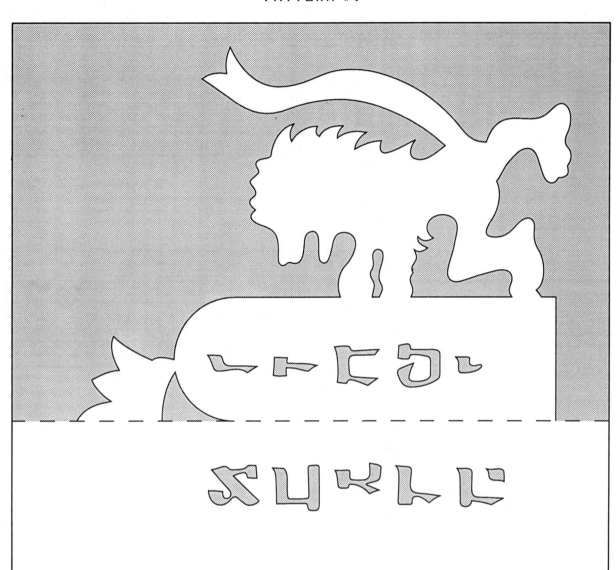

MIZRAH I

This next pattern is a *mizrah*. It has quite a bit more detail than the last pattern. It is possible to cut this out using very small manicuring scissors or a utility knife. If you want to add your own touches, you might add lines to the lion's mane or add cut-out shapes above or below the Hebrew letters spelling *mizrah*. Draw your additions on the back of the pattern before cutting them out. Remember to cut out the whole design folded, and then unfold the paper to cut out the Hebrew letters.

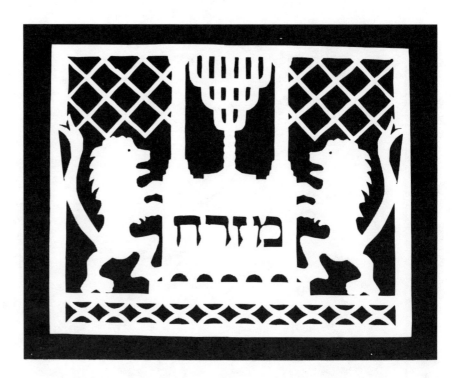

MIZRAH 2

This *mizrah* incorporates architectural images of Jerusalem and includes a Hebrew verse, which translates, "From this direction comes the spirit of life." When cutting out the shapes around the crisscross border, it might be a good idea to cut, not directly on the lines, but just on the outside, to make the lines a little thicker. Remember to unfold the papercut to cut out the Hebrew letters.

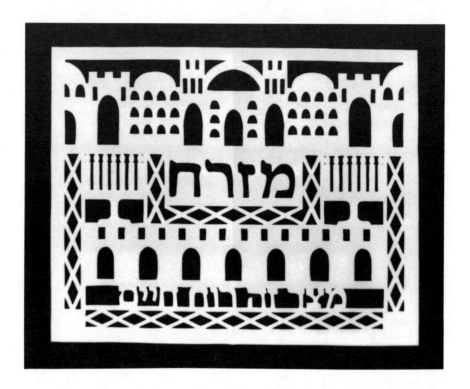

SHIVITI

This pattern for a *shiviti* would be most easily completed using a utility knife, but some people may find very small manicuring scissors sufficient. Remember to unfold the paper before cutting out the Hebrew letters.

To add personal touches, it might look nice to add some other floral or leaf shapes in the circle underneath the Hebrew letters.

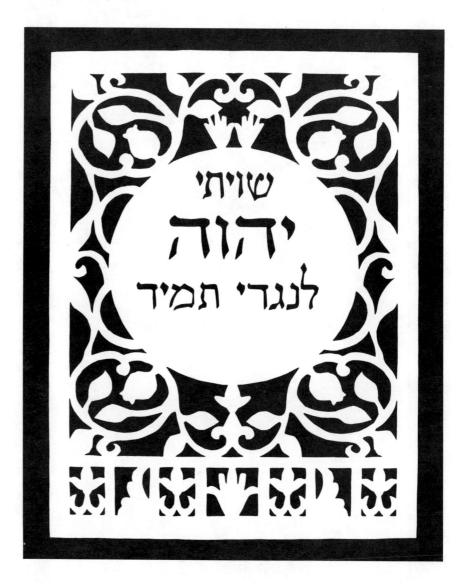

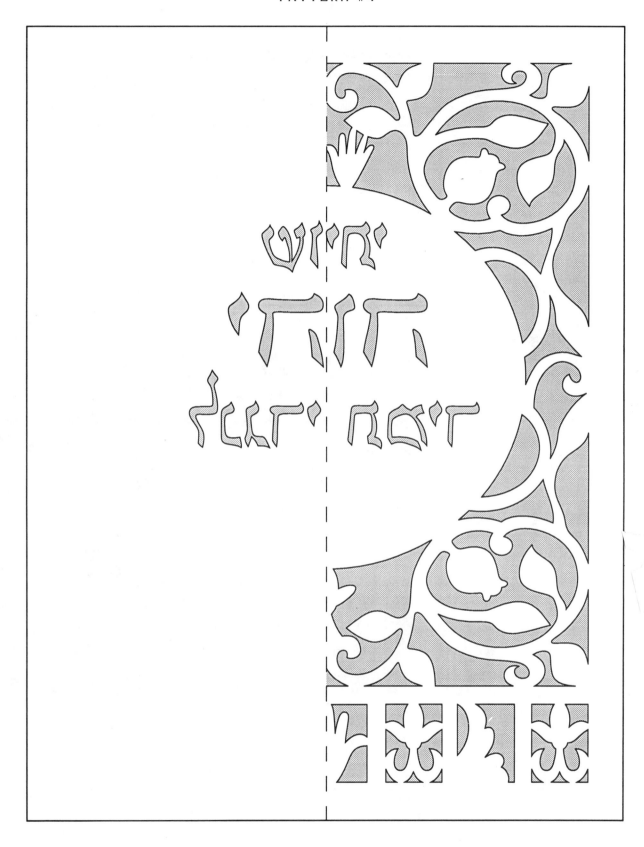

BORDER DESIGNS 1 AND 2

The following two patterns are border designs that can be used as decoration for a certificate or document. It will probably be easiest to cut each one using a utility knife. Either pattern can be utilized to decorate an existing certificate or document, or a certificate can be written directly on the papercut after it is cut out. Whichever way you choose to go, the patterns should be enlarged so that the center rectangle, which will be cut out, will be large enough for your certificate to show through or for you to have a large enough space to write what you want.

To decorate an existing certificate or document that you already have, cut out the whole design, including the center rectangle. The center can be cut out with scissors, but it should be cut out last. Next, choose a contrasting background paper. The total size of this background paper must be at least as large as the papercut. If a border of

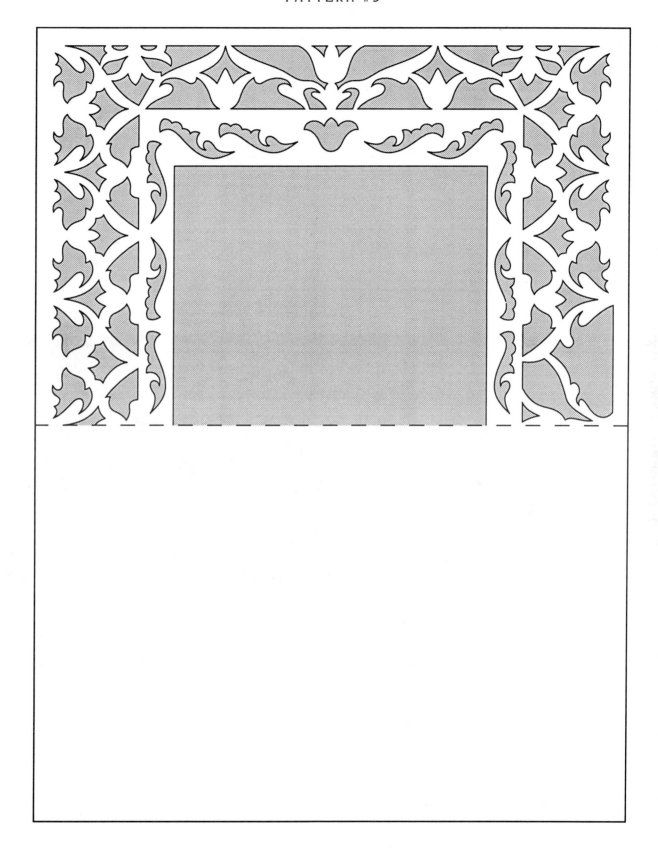

contrasting color is desired around the completed papercut, the contrasting paper should be larger than the papercut. A window will be cut out of the background paper that is ½" smaller than the rectangle that has been cut from the center of the papercut. That way a ¼" border of contrasting paper will show on the inside edge of the rectangle on all four sides. When you measure the background paper to cut out the window, be sure to measure from the center of the paper, so that the window will be in the correct place when the papercut border is attached to it. After the papercut is attached to the background paper, any certificate or document can be placed behind it, and it will show through the window.

Another way to use these patterns would be to cut out the design without cutting out the center rectangle. When the cut is completed, turn the paper to the front and write or draw whatever you want onto that center section.

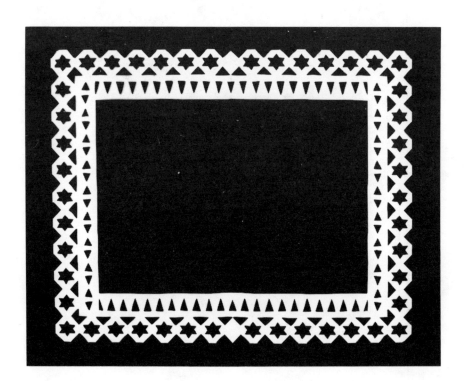

PATTERN #6

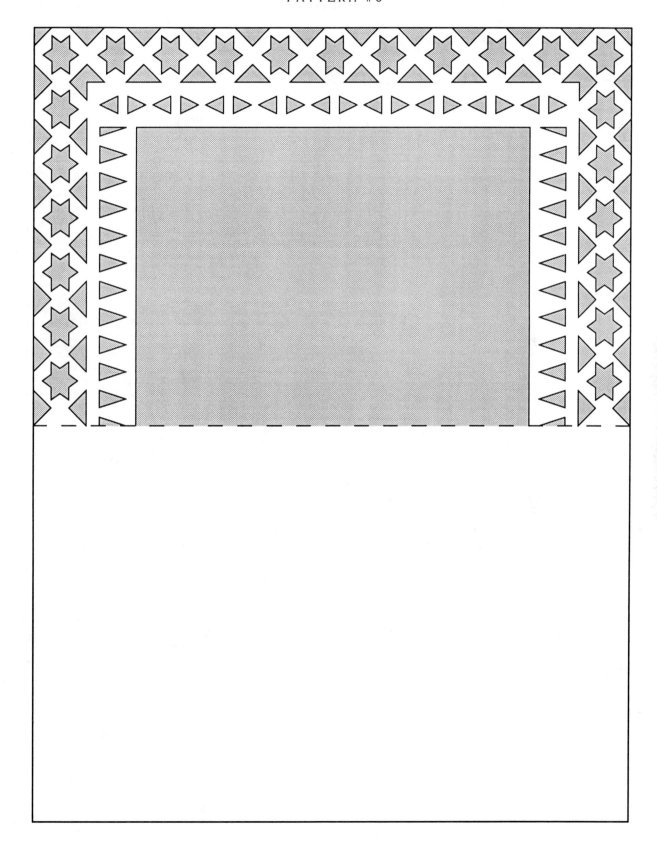

CHANUKIAH

There is no record of papercuts used for the holiday of Chanukah. Yet, it is a holiday that gives children an opportunity to decorate their homes. The following pattern is simple enough for children to cut out with scissors, and it should be enlarged by at least 33 percent to make it easier for them. Regular children's scissors will work fine, except for the few tiny enclosed spaces, but using manicuring scissors will work best for the whole pattern. Using a hole punch to make a space in the large areas to be cut may assist children in starting to cut this pattern. Otherwise, they may accidentally cut through the border. When the cut is complete, a Hebrew letter can be drawn on each of the *dreidels* on the front of the design.

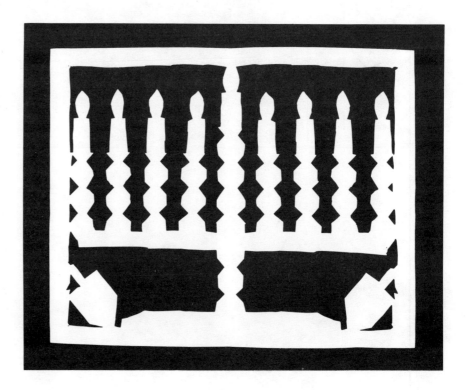

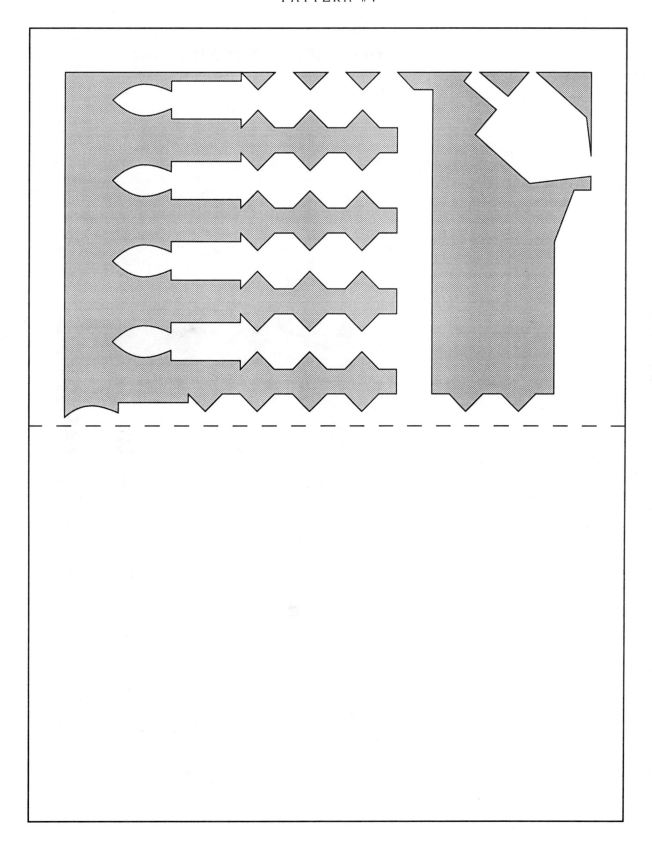

SUKKAH DECORATIONS 1 AND 2

The following two patterns, intended as *sukkah* decorations, can be made in a few different ways. As described in the chapter on the origins of papercutting, *sukkah* decorations were made by folding two pieces of paper into a booklet before cutting. To do this, you need only one copy of the pattern you plan to use along with a blank sheet of paper the same size. A booklet can be made by folding both sheets of paper down the middle. The pattern should be showing on the top with the blank sheet inside, with both sheets folded along the same line, to form a booklet. You can sew a basting stitch along the fold using a regular needle and sewing thread. If you have access to a stapler with an extra long arm, you can staple the sheets together along the fold line. Two or three staples along this line are plenty.

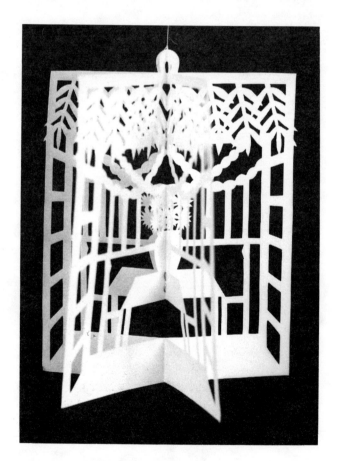

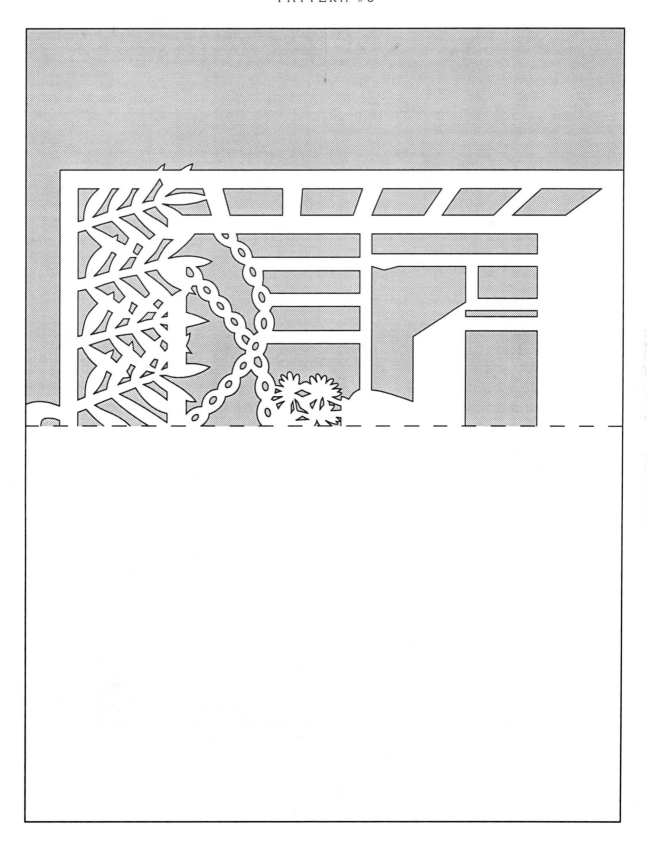

It takes more pressure to cut through four sheets of paper, so remember to keep your blade sharp. There are some rather small connecting lines surrounding spaces to be cut out. Keep the knife perpendicular to the paper when cutting around these spaces to assure that you don't cut through those lines. Some people may find the centers of the chain images in the pattern resembling a *sukkah* difficult to cut. The papercut will still look fine if these centers are left uncut.

When the cut is complete, open the booklet carefully so that there are four sides at right angles to each other. Tie a string at the top hole and attach the other end to the roof of your *sukkah*.

Taping the bottom may help to add weight to the decoration, as well as to help keep the sides open at right angles. Take small pieces of Scotch transparent tape and fold them with the sticky side out. Stick the tape close to the bottom of the inside of each fold, with the fold of the tape at the fold of the decoration.

If you prefer, either pattern can be used in the same way as the others were—without making a booklet—by pasting it to the back of a contrasting paper to decorate the walls of your *sukkah*.

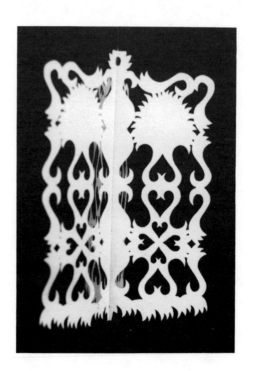

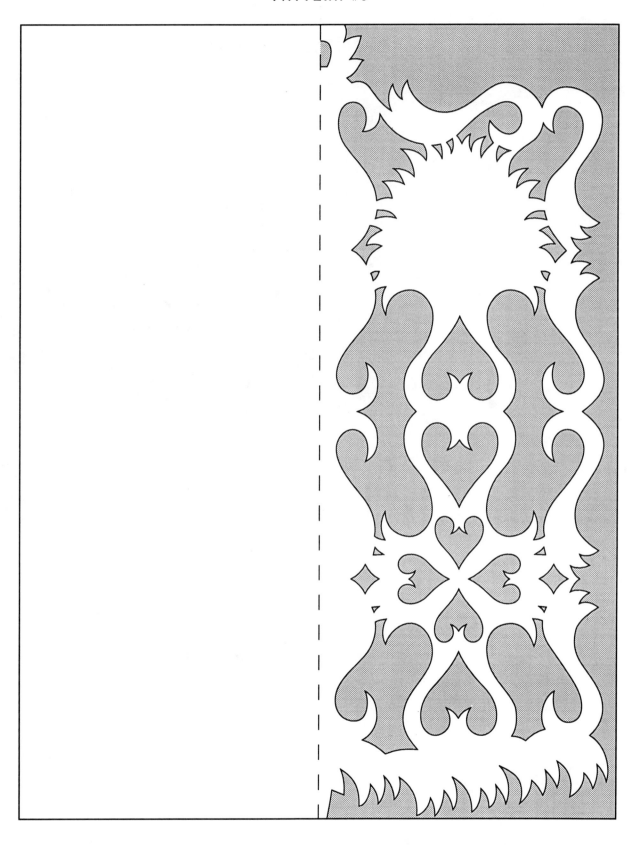

ROYSELEKH FOR SHAVUOT

This pattern for a *royselekh* is a decoration for the holiday of Shavuot, although it can be used any other time of the year as well. Because this design is so intricate, it may be easier to cut if it is enlarged by 33 percent, although you will need to use a utility knife in any case.

Traditionally these Shavuot decorations were taped to the windows of the home without a contrasting background paper. Using a background paper for the papercut may give it a longer life since the design is rather delicate. The choice is yours.

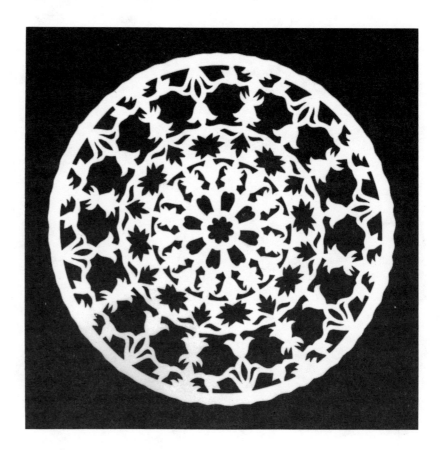

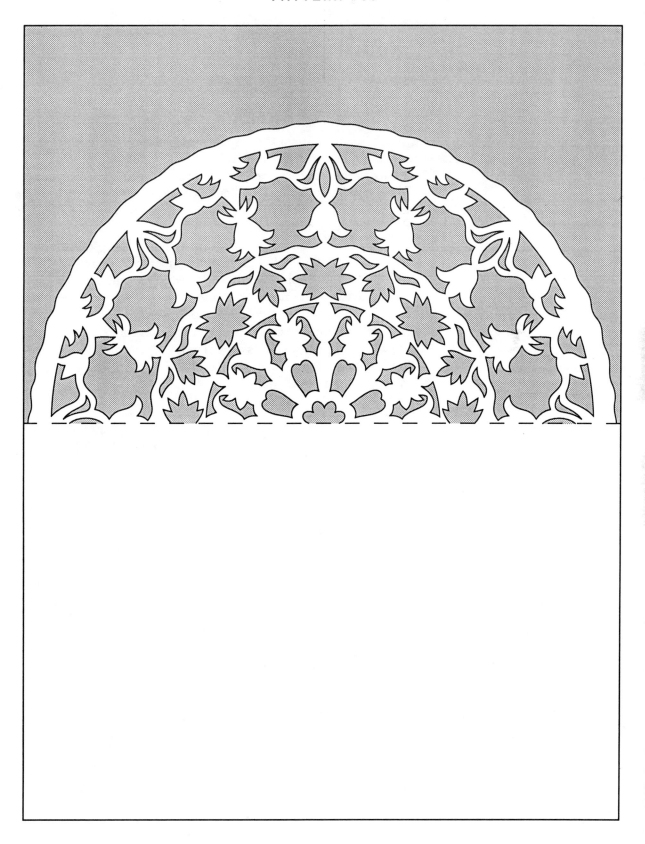

ROSH HASHANAH CARD

This pattern for a Rosh Hashanah card should be enlarged by 33 percent so that the outside border measures 8½" × 11". Once enlarged, the design can be cut out using a utility knife. Since this design is completely asymmetrical the paper is not folded before cutting. Simply cut along all the solid lines through the single layer of paper. Next, cut away the excess paper along the solid border line. Then, carefully fold the paper into a card by first folding the sheet exactly in half along the 8½-inch line. Fold the sheet in half again to form the card with the design showing in front.

For the contrasting background, cut a piece of colored paper 3⅞" × 5⅛". Attach this background sheet to the back of the cut-out panel by putting rubber cement (or whatever glue you choose) just along the top of the sheet. First fold the papercut into a card, and then unfold it to attach the contrasting paper evenly.

Fold the card back up, and you now have a Rosh Hashanah card to write your personal message. The Hebrew words in the design are the traditional Rosh Hashanah greeting and translate, "May you be inscribed for a good year."

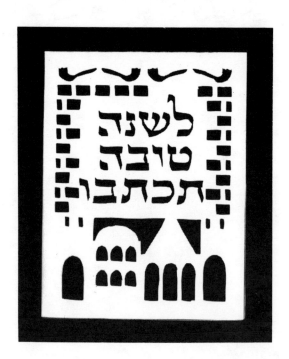

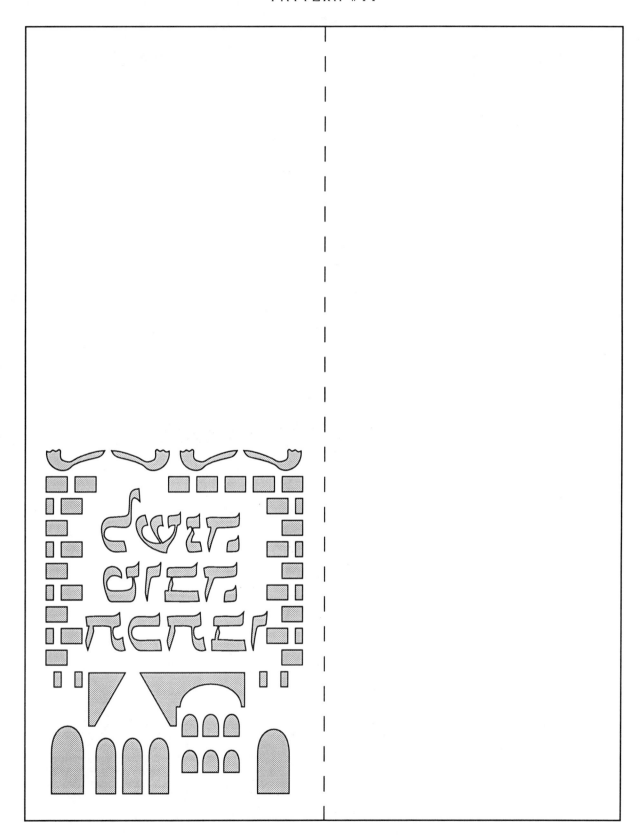

CHAPTER 4

CREATING AN
ORIGINAL PAPERCUT

Using the patterns in this book to create papercuts is a helpful way to learn the art form and to practice cutting. As you become more skilled, however, you may want to express your creativity further by designing your own papercut. This process is more detailed than relying on the patterns presented in the book. To understand the process completely, as well as to familiarize yourself with the materials and tools, read all the sections of this chapter thoroughly before beginning.

Deciding on a theme and developing a design involves research and thought. It sometimes takes longer to plan and draw your design than it does to cut it out. Some people may be able to cut out a papercut with a rough outline drawn on the back of a piece of paper. Most people will want to have an exact drawing before starting to cut. Taking the time to execute an exact drawing gives you the opportunity to develop a well-thought-out design. This can help to prevent the possibility of making irreversible cutting mistakes along the way.

To help you decide on the kind of papercut to create, look through the patterns or recall the various types of traditional papercuts discussed in the chapter on the origins of papercutting. An approaching holiday or special occasion might also give you an idea as to a theme for your papercut.

DEVELOPING THE DESIGN

Once you have an idea or theme in mind, begin the process of developing it into a design. Start by thinking about what images you may want to include in your papercut. It is not necessary to draw strictly from memory. There are a multitude of sources that can be helpful for inspiration, as well as for more practical assistance in drawing. A trip to the library might be in order here. Look through other Jewish art books for ideas for design and style. Architecture, particularly when it represents Jerusalem and the Temple, is traditional to Jewish papercutting. For ideas and examples of these architectural shapes, look through books of photographs about Israel. Or, closer to home, look through your own photo album from Israel or through that of a friend. I have used my own photo album many times. Nature books or even gardening or nursery catalogs are a good source of ideas for trees, flowers, and other foliage. Likewise, books about wildlife can provide assistance in drawing animals. Children's books can be useful because pictures are sometimes drawn or photographed more simply.

Books are not the only source for inspiration and help in drawing. Study the patterns and pictures in fabrics, rugs, and tapestries. Patterns, textures, and pictures surround us everywhere, in the human-made and in nature. Look around you to see how your visual surroundings can be adapted to your design.

USING HEBREW TEXTS

Another way to further develop an idea for your actual design is by using Hebrew texts. Verses from the Bible, prayer book, holiday liturgy, or other writings can provide inspiration. For example, if a holiday will be the theme of your papercut, using a prayer said during that holiday or a biblical or talmudic passage that refers to the holiday can give you ideas for images and symbols to use. The prayer or verse itself can also be included in your papercut, in Hebrew and/or English. Look at the papercut on page 47 to see how a design can be based directly upon a biblical verse. There will be discussion of the actual drawing of letters further on.

Not being particularly literate in Hebrew, I always use English translations when searching for an appropriate passage or verse. Find-

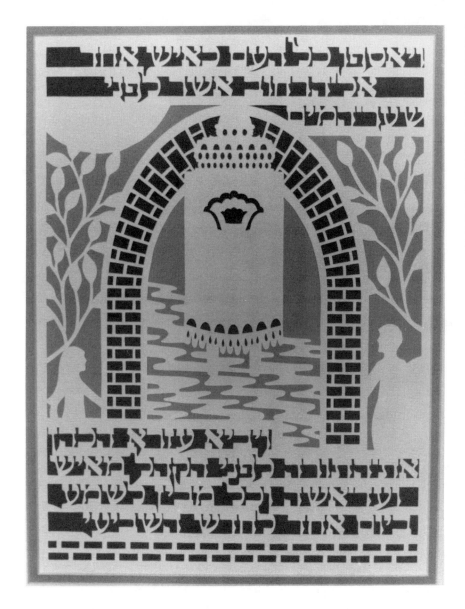

The design for this Rosh Hashanah–themed papercut is based directly on Nehemiah 8:1–2, which is incorporated into the papercut as well. The English translation reads: "All the people gathered themselves together as one into the broad place that was before the water gate. . . . And Ezra the priest brought the Law before the congregation, both men and women, and all that could hear with understanding, upon the first day of the seventh month."
Artist: Amy Goldenberg. 1991, artist's collection.

ing the corresponding Hebrew is easy. Many editions of prayer books include both Hebrew and the English translation. There are editions of the Bible with a column of Hebrew and English on each page. Verses in the Bible are numbered, so it should not be too difficult to figure out the corresponding Hebrew and English. If you are not absolutely sure, it is a good idea to check with someone who can read Hebrew to avoid mistakes.

Books about Jewish holidays are a good source for finding biblical verses to use in a holiday-themed papercut. The book will tell where the verses can be found in the Bible, so you can look up the corresponding Hebrew. These same holiday books are also extremely helpful in discovering things you may not already know about a particular holiday. Knowing as much as possible about a holiday will give you more to work with in deciding on ideas and symbols to use for your design.

DRAWING YOUR IDEAS

You will reach a point when you will want to start drawing or sketching some of your ideas. For your first design, start simple. It is best to get a feel for the technique and process of designing a simple papercut before trying to create something too elaborate or intricate. As your experience at papercutting develops, designing and cutting intricate designs will follow. One way to start simple is to attempt a symmetrical design. Traditional papercuts were usually symmetrical—each side being a mirror image of the other. Symmetry is achieved by pairs of images or one centrally located image whose halves are identical. Since both sides are the same, designing a symmetrical papercut is also half the work.

The most important thing to remember when designing a papercut is that all positive space (the paper) must be attached to other positive space. If there is negative space (a cut-out space) completely surrounding a positive space, that positive space will fall out. For a papercut to be well structured, it should not have too many large negative spaces, which will undermine its stability. Another thing to avoid is a cut-out area along more than one third of the entire length of the design horizontally or vertically, which will cause sagging. Structural stability in a papercut is as important as good design.

When you begin to lay out and draw your design, it should not be done on the paper you plan to cut. Any white paper will do, but you might consider using tracing paper. This see-through paper is particularly useful during the designing and planning process if you need to trace letters or any other shape you may not be able to draw freehand. Planning a symmetrical design is easier with tracing paper too. Sometimes it is difficult to visualize half of an image as a whole or to know how one image will look as a pair. With tracing paper you can draw half an image or one whole image, fold it at the line of symmetry, and then trace over the lines on the other half of the paper. When it is unfolded, you have a symmetrical image or pair of images. It is easiest to see lines drawn on tracing paper by working on a white surface. If your tabletop is not white, place a piece of white paper underneath your tracing paper while you work.

LAYING OUT THE DESIGN

Choosing the way to lay out your design depends upon many factors involving both structural and aesthetic concerns. Some of the design decisions you will be making include what images will be a focal point, how much decoration you want in relationship to the images you choose, and how you will divide up the whole space yet keep it connected, to insure a balanced and structurally sound composition. One way to begin making these decisions is to think of your design as separate elements that need to be united: the border, central imagery, background patterns and decoration. Every papercut will not necessarily include all these elements, but understanding how they function in design and structural stability will help you plan the layout of your papercut. Drawing lines on your paper to separate it into these elements begins to give your design a basic layout and defines different areas to fill with the images and decoration you want to include. Some images might be utilized best as central images. Other images or decoration might work better in a border or as a background pattern. A tree might be a focal point in one design but in another, branches and leaves might be better suited as background decoration. These decisions will be based upon the size of your papercut and its basic layout, but any shape or image can be a part of any element in a design. To think otherwise will limit the creative process.

CREATING A BORDER DECORATION

The use of a border decoration frames a design. Borders can also help to add visual stability. The width of the border is a matter of personal taste but also depends on what images or decoration will be included in it. The use of Hebrew and/or English letters as positive space in a border works well because letters can be attached at their top and bottom by bands of solid paper that will enclose the border without being distracting to the rest of the design. Borders can also be made up of a repetitive shape or image that relates to the whole theme of the papercut, but may not work as a central image. The papercut below, with its double border, shows how letters and a repetitive image (in this case a *shofar*) can be used as a border. The *shofar* is also repeated among the central imagery. Borders can also be purely decorative, while still matching the overall style of the design. Borders, whether of letters or decoration, need not encompass all four sides of the design. Having a border along the sides and top only or just at the top and bottom are options to consider for layout.

The English translation of this Rosh Hashanah–themed papercut reads: "In the seventh month, in the first day of the month, there shall be a solemn rest unto you, a sacred occasion commemorated with a blast of horns" (Leviticus 23:24). Hebrew letters and images can be used to create borders. The double border of this papercut shows examples of both. The image of the *shofar* is repeated 100 times in this papercut because you hear the sound of the *shofar* 100 times on Rosh Hashanah. Artist: Amy Goldenberg. 1989, artist's collection.

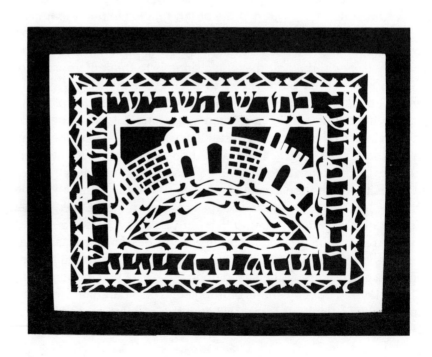

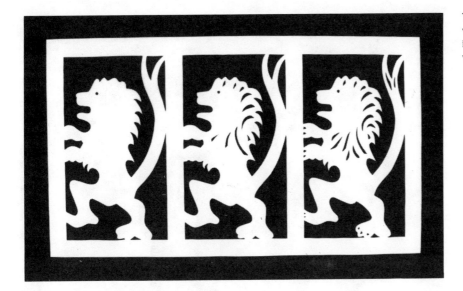

The addition of cut-out areas within the lions adds detail to the image, but you can tell it is a lion without these additions.

PLANNING THE CENTER IMAGES

Central imagery refers to distinct images that are a focal point simply by their placement or size. It is important to carefully plan the layout of central images because their placement and connection to each other will determine the placement of other elements. One way to lay out central imagery is by further dividing the main area within the border by lines or geometric shapes and by placing images within these newly created areas. As a focal point, central imagery is generally positive space. The outline of a central image will give it a basic shape, but the addition of cut-out areas within an image is what gives it detail and depth. A tree may not require additional detail within, but an architectural image will probably need it. Some shapes, such as an animal, can go either way, depending on their size. Look at the example of the lions above to see how the addition of cut-out areas within an image adds detail. The architectural images on page 52 clearly show how some shapes will definitely need more detail to show what they are.

The addition of cut-out areas within the architecture is necessary to see clearly that it is, indeed, architecture.

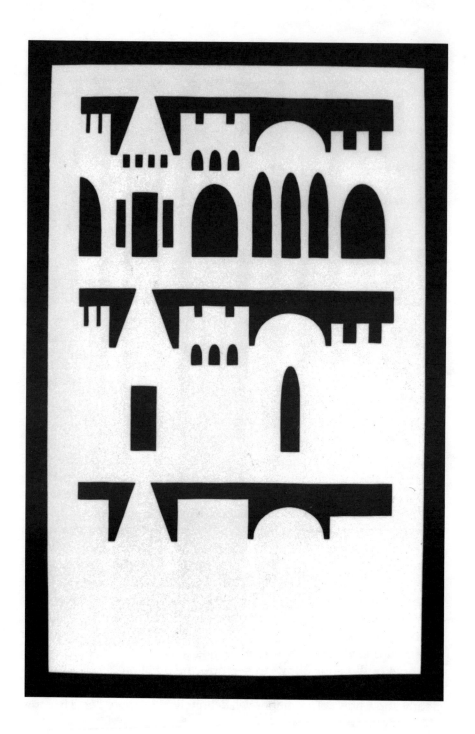

ADDING BACKGROUND PATTERNS

Background patterns are also integral to your design when there are large areas of negative space that need to be filled. Their use and placement contribute to the balance and structure of the overall design as much as central images do. Background patterns can add a sense of unity to a papercut by tying separate elements together, visually and structurally, into a distinct whole. How the lines of the background pattern connect to central images is important. You can lose the distinct shape of a particular image if the placement of connecting lines is not well thought out. An intricate background may look striking against simple, undetailed images, or a simple background may be an option so as not to distract from intricately cut-out central images. Total simplicity or total intricacy are also possibilities. These decisions are a matter of taste, as well as your level of skill at designing and cutting.

DRAWING HEBREW LETTERING

An often-found image in Jewish papercuts is Hebrew lettering. This warrants some discussion of how to draw them. In the final papercut, Hebrew letters can be either positive or negative space. As a general rule, final *mem* (ם) and *samech* (ס), must be positive space, as their centers would fall out if they were negative. Refer to the diagram on page 54 to see a technique of designing these two letters so they can be utilized as negative space. When letters will be negative space, it is possible to use a typeface where the letters have thin lines. As positive space, the thin lines of some letters may not be sturdy enough. When cutting positive letters, if the lines are too thin, there is a greater risk of cutting through them. English letters may work best as positive space because so many of them would suffer the same fate as final *mem* or *samech*. If using both Hebrew and English letters, the typeface styles should be similar. The typeface found on page 55 may be helpful in tracing Hebrew letters if you cannot draw them freehand. The letters can be enlarged or reduced on a photocopy machine if their size is not right for your design.

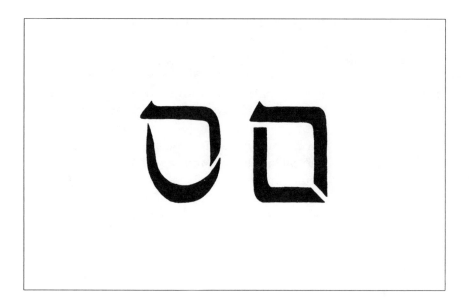

MAKING LETTERS THE CENTRAL IMAGE

Letters have been discussed in their use as a border element, but they can also be used as central imagery. Here, lettering becomes a focal point of the papercut. Use of both the Hebrew *and* English of a particular verse will mean that a large part of the design will be letters. When the size of a papercut is not very large, this could make it difficult to fit all the lettering within the border. When you want to include detailed imagery in addition to a lot of lettering, you will have to plan the size of your papercut accordingly. The English will generally take up more space than the corresponding Hebrew. When utilized as central imagery, letters as negative space might be an option to consider because they can create a pleasing visual contrast to other central imagery of positive space. Having letters of both positive and negative space in one papercut can also have an interesting effect.

Another important point to remember about letters in your papercut, in either Hebrew or English, is to be sure to double- and triple-check the spelling of any words. This point reminds me of one of the golden rules of carpentry: "Measure twice, cut once." A misspelled word in a piece of artwork is worse than finding a typo in a book.

אבגדה
וזחטיכך
למםנןס
עפףצץ
קרשת

This alphabet can be used as a guide when you are including Hebrew letters in your design. You can choose to draw your letters freehand, or they can be traced directly from the book. If the size isn't right, enlarge or reduce the letters on a photocopy machine.

This Hebrew alphabet was created by Francine Carroll Oller.

This papercut was a commission for Laila Poveda and Shaye Remba and was used as the cover of their wedding invitation. This shows an example of how some images can work as either positive space or negative space. You will notice that the negative shapes around the Hebrew letters are similar to the positive shapes in the border surrounding them. Artist: Amy Goldenberg. 1989, Poveda-Remba collection.

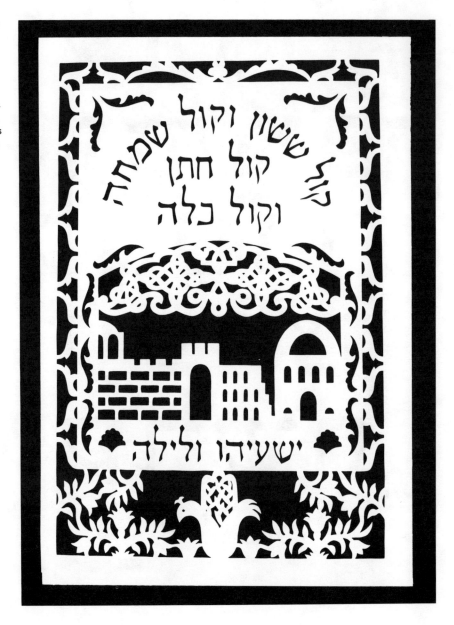

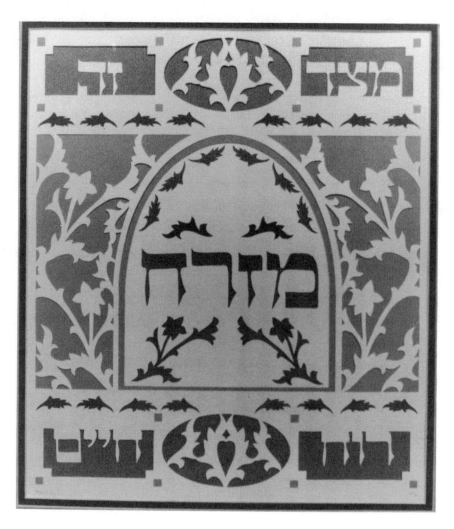

This *mizrah* demonstrates using the same image as both positive space and negative space within the same papercut. The flower and leaf images, cut out as negative space to surround the Hebrew letters, are enlarged and repeated as positive space bordering the arch. Hebrew letters are also used as both positive and negative space.
Artist: Amy Goldenberg.
1990, artist's collection.

SYMMETRY VERSUS ASYMMETRY

Balance and composition do not necessarily mean symmetry. As you become more skilled at designing and layout, creating an asymmetrical papercut might prove more challenging. This will involve more time and thought to create a balanced design. In an asymmetrical papercut, you are designing the entire space, rather than half of it as with a symmetrical papercut. An asymmetrical design can be achieved in three different ways: it can be a set of symmetrical elements placed asymmetrically, a set of asymmetrical elements placed in a symmetrical fashion, or it can be totally asymmetrical in its elements and the placement of those elements. The papercuts on pages 59 and 60 show examples of asymmetry. In the first, each oval is different, but they are placed symmetrically within the central part of the design. In the second papercut, the central imagery is completely asymmetrical, yet balance is achieved. The symmetrical border also frames and adds to the overall balance.

CONSTRUCTING WITH DRAFTING TOOLS

The use of drafting tools may be helpful when drawing your design. Drawing with tools is called constructing. These implements range from the very basic to the very complex. The three most basic tools are the straightedge, the triangle, and the compass.

The straightedge is the most useful tool. It is used to draw straight lines. A ruler is a straightedge with markings used to measure distances in addition to drawing straight lines. In advanced drafting, the two are separated into an unmarked straightedge and a measuring device called a scale. One kind of straightedge is a T-square, which has a perpendicular attachment at one end. When pressed against the straight side of a drawing table or board, a constantly horizontal line is ensured. A scale usually has many sets of markings in different increments and is meant to be used for measuring only, not for drawing lines. A "parallel rule" is the ultimate in straightedges. It is attached with wires to a drawing board or table and remains perfectly horizontal as it is moved up or down.

A "triangle" is a triangular device usually having angles of 45, 45, and 90 degrees or 30, 60, and 90 degrees. When the straightedge is placed along a horizontal line, the triangle is placed next to it to

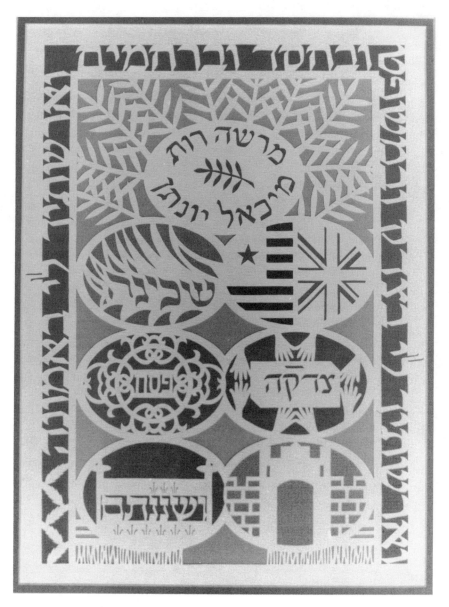

This very personalized papercut was commissioned for Rabbi Marcia Plumb and Michael Shire and used as the cover of their wedding invitation. The Hebrew border reads: "And I will betroth thee unto Me in righteousness, and in justice and in loving-kindness, and in compassion. And I will betroth thee unto Me in faithfulness" (Hosea 2:21–22). Dividing the central space into seven ovals was decided upon to represent the seven years between their first meeting and their engagement. In addition, the verse they chose is traditionally said when putting on *tefillin*, which are wrapped around the arm seven times. The images in each oval represent symbols of their identities and/or important aspects of their lives and their relationship. This papercut is a good example of how space can be divided in a symmetrical way, but filled in asymmetrically. Artist: Amy Goldenberg. 1990, Plumb-Shire collection.

This papercut was a commission for Lauren Krieger and Lorette Herman and used as the cover of their wedding invitation. The English translation of the Hebrew is: "The voice of joy and the voice of gladness, the voice of the Bridegroom and the voice of the Bride." The symmetrical border frames an otherwise completely asymmetrical design.
Artist: Amy Goldenberg.
1989, Krieger-Herman collection.

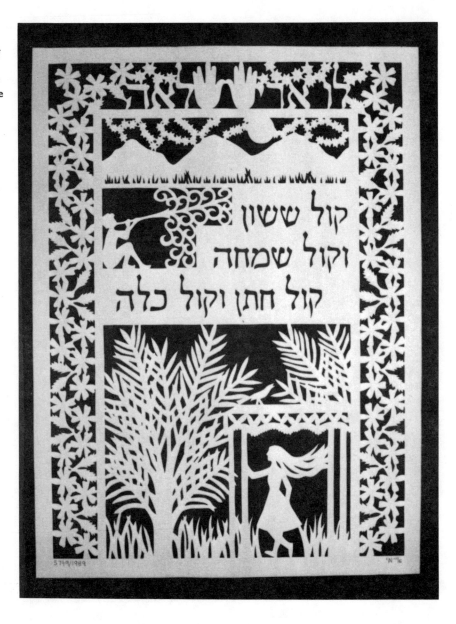

yield a perfectly vertical line. The 45, 45, and 90 degree triangle will be more useful, as it can also be used to miter corners in designing borders for your papercut.

A compass is a tool used to construct perfect circles or circular arcs. The drawing end pivots around a stationary point, and it can be adjusted to construct circles of varying sizes up to about twelve inches. Larger circles can be drawn with a set of compass points that attach to a wooden yardstick. This tool is necessary when you are creating large circular papercuts.

Templates are somewhat more advanced tools, but are easy to use and very helpful. A template is a piece of plastic with either positive or negative spaces of varying shapes and sizes. Circular templates have circular cutouts (negative spaces) in assorted sizes. These are useful in drawing very small circles or in designing circles without having to find the center of each circle. Oval templates are similar and allow for designing with ovals without having to construct them mathematically. I have found oval templates particularly useful when drawing arched windows in architectural images. "French Curves" are odd-shaped templates that are used to construct shapes that contain arcs of varying degrees. A protractor is a template that divides space into 360 degrees. This is useful for dividing circles or other shapes into exact parts.

For increased accuracy when constructing with drafting tools it is suggested, although not mandatory, to use a mechanical pencil. The lead always remains sharp, and the metal tube that shields the lead keeps the pencil at the same distance from the tool you happen to be using. Accuracy is maximized by striving to hold the pencil at a constant angle to the paper. If using a regular pencil, frequent resharpening may be necessary.

Another helpful tool, not used for drawing, but for erasing, is an eraser shield. This thin piece of flexible metal is about the size of a credit card with cut-out areas of different shapes and sizes. When the shield is placed on the paper, with a cut-out area exposing pencil lines to be removed, you can erase them without removing surrounding lines. On intricate designs with lines that are close together, this inexpensive little tool prevents a lot of frustration caused by erasing lines that you want to keep and then having to draw them over.

All these tools can be found in the drafting or graphics section of an artist's supply store. It is not necessary to buy all these tools at once just to get started. Begin with the basics, and invest in the others

The Hebrew surrounding the center circle is from Genesis 2:3 and reads: "And God blessed the seventh day and declared it holy, because on it God ceased from all the work of creation which God had done." This is another example of using biblical verses to design a papercut. It also demonstrates how space can be divided symmetrically, but filled in an asymmetrical fashion. Starting at the upper left, and moving in the direction that Hebrew is read, each of the six sections surrounding the center represent each day of creation. The center is, of course, *Shabbat.*

This papercut was used as the cover of the *bar mitzvah* invitation of Jonathan Ehrlichman. The verse is from his Torah portion. Artist: Amy Goldenberg. 1992, Ehrlichman collection.

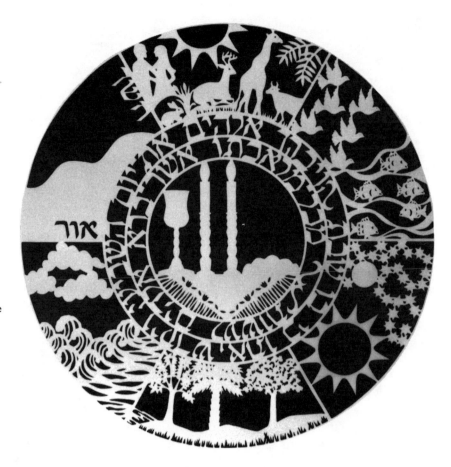

when you feel the need for them. Large oval templates were a worth-while investment for me because I like to use oval arches in my designs. Someone who prefers the look of straight lines may not find a use for them. If you know a graphic artist or architect who doesn't mind lending tools, you can try them first before you purchase them.

Some people may not like the idea of drawing their designs using drafting tools. They may think it takes away from the homemade quality of the art form. When you begin cutting, it will all be done by hand. I have found that, while I rarely cut as perfect a circle or arch or as straight a line as I had drawn, I am always happier with the finished product when I had started out with an accurate drawing. After all, it is easier to cut a straighter line when you are cutting from a drawn line that is straight.

CHOOSING PAPER

When you take the time to design an original artwork, it follows that you choose the materials with care. In the case of papercutting, the quality of the paper is of the utmost importance.

The paper discussed in the previous chapter was a thin bond variety that enables you to fold it prior to cutting. Because paper becomes more fragile and brittle over time, there are other types of paper that may be more desirable to use. A 100 percent rag paper that is acid-free or pH neutral will slow down the aging process of your work by hundreds, if not thousands of years. Paper that is 100 percent rag means that it is made entirely of cotton fiber and contains no wood pulp. This is the most permanent kind of paper. Acid-free means the paper has no acidic content. The scientific term pH neutral refers to the pH scale, which is used to express the acid or alkaline content of a given substance. The scale runs from 0 to 14, with 7.0 being pH neutral. The acidic content *increases* as the numbers on the scale *decrease*. Papers with a pH level that are higher than 7.0 are also safe, since acidic content is what you want to avoid. Having acidic material present in the paper fibers is what causes the paper to age and turn yellow and brittle over time. Not all 100 percent rag paper is acid-free. Some papers are treated chemically to remove any acid content or might be buffered with calcium carbonate, an alkaline substance, to raise their level on the pH scale and to serve as a buffer for any acidic material that might come in direct contact with

the paper. When you shop for paper, be sure it says 100 percent rag and acid-free.

Besides fiber content, the other consideration when shopping for paper is thickness. Thickness of paper is measured in weight or ply. As a general rule, "90 pound" or "2-ply" paper is preferable for papercutting. Arches watercolor paper comes in a 90-pound weight, either hot pressed, cold pressed, or rough and is fairly easy to cut. Hot, cold, and rough refer to textural differences resulting from the manufacturing process of the paper. Hot-pressed paper has the smoothest surface, and cold-pressed paper has a slight texture. I like the rough-textured paper. The surface texture adds a nice accent to the finished product. One side is rougher than the other, and the smoother side, which is the easier surface on which to draw, will be the back of your papercut. Watercolor paper in 140-pound weight is harder to cut and may be too thick for some people. Others may prefer its stiffness for some projects. There is a 2-ply medium paper such as the Strathmore Bristol 400 Series paper that has a smooth surface. It cuts easily and cleanly.

Good-quality rag papers are made for a variety of artistic uses: printmaking, painting, or drawing with charcoal, pencil, or ink. All rag papers are not necessarily well suited for papercutting. Some rag papers will actually feel like a piece of cloth to the touch. I have found these papers to be more difficult to use for papercutting. Even after cutting completely through the paper, I still pull out little wisps of paper fibers when I remove the cut-out piece. This can be very frustrating when a clean-cut edge is desired. None of the papers described in the previous paragraph have this characteristic. On the other hand, if you prefer wispy edges in your papercut, you might want to use the kind of paper that allows for this look.

Watercolor paper, or any other rag paper you choose, is generally thicker than bond paper and comes in large sheets usually measuring 22" × 30". This type of paper is too thick to be folded for cutting, so it must be cut unfolded, through a single layer of paper. The finished papercut will be sturdier and less fragile to handle than one made of a thin bond paper. Buying paper in large sheets is more economical than buying a whole pad of paper. Good-quality paper sold in pads can be rather expensive. Purchasing by the sheet allows you to experiment with a variety of papers with minimal investment. In addition, you are not restricted in the size of your papercut with a larger sheet of paper. Spend time exploring the paper section at a well-stocked artist's supply store to discover your preferences.

TRANSFERRING THE DESIGN

After you have finalized your design, you will need to draw it onto the *back* of the acid-free paper you have chosen. Rather than drawing your design directly onto this paper, it is a better idea to transfer it from a separate piece of tracing paper. If you have developed your design onto tracing paper from the start, you are one step ahead. There are a few reasons why transferring your design from tracing paper is advisable. First, this will enable you to keep a copy of your design. This is valuable because if you accidentally make an irreversible cutting mistake that cannot be repaired, you won't have to start drawing from scratch when you begin again. Also, it will save your final paper from the prospect of being ruined from erasing and redrawing when you lay out and draw the design. In addition, remember that a design is drawn out *backwards* on the back of the paper to be cut. When it is drawn out on tracing paper first, it is drawn out forwards. This can avoid confusion and mistakes during the drawing and designing process, especially when Hebrew letters are a part of the design. The design is drawn with pencil on the tracing paper and, when the tracing paper is turned over, the pencil's graphite is transferred from the tracing paper onto the acid-free paper.

Even if you transfer your design from another piece of paper, it is likely that you will still need to use an eraser on your final paper. Everyone makes mistakes. Erasers found on most pencils, while they remove pencil lines, also remove paper fibers. This can ruin a nice piece of paper. If you need to use an eraser, the Artgum eraser or Magic-Rub eraser are types that will remove pencil lines without taking any paper fibers with it. It is also a good idea to use a flat, wide, dry brush to remove eraser crumbs, rather than to wipe your hand across the paper, which can leave oils from your skin. Blowing them off is another no-no, as the moisture from your mouth can ruin the paper as well.

Here are the step-by-step directions to make the transfer from tracing paper to your acid-free paper:

1. Draw the outside dimensions of the design onto tracing paper (that is the total size of your papercut). Using a straightedge and triangle will allow for construction of a more precise rectangle. A compass for constructing large circles should be used at this point if your design is circular.

2. Draw your design within this space on the tracing paper, including a band of solid paper surrounding the design. A one-half-inch band generally looks best. Any symmetrical parts of the design (that is any parts that will be exactly the same on both sides) need to be drawn on one side only. If your papercut will be mainly symmetrical, draw a vertical line down the center of the design space. This way you will see exactly where everything will meet in the center. You will also avoid drawing over more than half of the space, which would create problems when you are transferring the design. Asymmetrical parts, such as Hebrew letters, should be filled in where they belong.

3. Your acid-free paper should now be cut to the desired size from the large sheet you have purchased. First, use a straightedge and triangle to draw the outside dimensions of your design on the back of the acid-free paper, or use the compass for constructing large circles, if your design is circular. Also, draw a vertical line down the center, the same as you did on the tracing paper if your design is mainly symmetrical. When you cut this out from the large sheet, do not cut along the lines indicating the outside dimensions of your design. Cut farther out from the lines, about one to two inches all around. If your design is circular, the paper should be cut into a square one to two inches larger than the circle. The extra paper will be needed later when you are ready to frame your work.

4. After you make sure the table is clean and dry, tape your acid-free paper to it with the back side up. Use small pieces of masking tape at the corners. The border of extra paper around your outside dimensions serves a purpose here, too, preventing you from having to place tape where the drawing will be. Drafting tape might be preferred over masking tape. Drafting tape is specifically designed for temporary holding and is less tacky on the back than masking tape. When you remove it from the paper, after you have drawn out your design, no paper will be torn off with the tape.

5. If your design has distinct elements divided by straight lines, circles, or ovals, such as lines that separate the border from the central imagery or a set of images surrounded by a geometric shape, these boundary lines should be drawn directly

on the back of the acid-free paper, using your drafting tools. These constructed lines will be more precise than if they were transferred freehand from the tracing paper. Draw these lines throughout the design, regardless of symmetry. Be sure to measure each section carefully, to coincide with the measurements on your tracing-paper drawing.

6. Turn the completed tracing paper drawing over, face down, onto the acid-free paper. Align the outside and center lines of both papers, as well as any boundary lines you drew in step 5. The design will appear backwards. Using a firm hand, and using a sharp pencil, trace over the lines. If it helps, tape down the piece of tracing paper to keep it from moving.

7. To draw the mirror images of the symmetrical parts, turn the tracing paper over, realigning the center line, boundary lines, and all design lines that touch the center line. Go over the lines of the symmetrical parts once again, using a firm hand. When you had transferred the first side of the symmetrical parts from the tracing paper, it produced the pencil graphite needed to transfer the design onto this second side of your acid-free paper.

8. After the transferring is complete, go over any faint lines on the acid-free paper to be sure you can see the design clearly.

If you want to create a papercut on acid-free paper, but don't feel ready to design your own, tracing paper will also enable you to transfer a design from this book. Patterns #2 to #7, which have an obvious border, are best suited for this because you will be able to frame them. Patterns #1 and #10 do not extend to the edge of the paper, making them difficult to frame. You may not want to use those patterns when you work with better-quality paper. In Patterns #8 and #9, the *sukkah* decorations, it would be extremely difficult to cut through four layers of thicker paper. You may want to skip those as well when you use quality paper.

If you do not intend to enlarge the desired pattern, to copy it from the book, place a piece of tracing paper over it and go over the lines with a pencil. If you want to enlarge a pattern, use a photocopy machine to enlarge it to the desired size, as described in chapter 2. Then trace the pattern from that copy. Next, follow the aforementioned steps 3 to 8 to make the transfer onto acid-free paper. Some of these

patterns include Hebrew letters, which add the following extra step. After you have transferred the pattern from tracing paper onto acid-free paper, excluding the Hebrew letters, go over the letters with a pencil on the side of the tracing paper where they appear forwards. Then turn that over onto the back of the acid-free paper and trace over them once again. The letters should now appear backwards on the acid-free paper. Remember, the patterns in the book are drawn backwards. If you had transferred the letters onto the acid-free paper in the same way as the rest of the design, the letters would have appeared forwards, when they need to be backwards.

Pattern #11, the Rosh Hashanah card, may be difficult to fold when using thicker paper, but it can be done with a slight variation. Since this pattern works best when it measures 8½" × 11", use a photocopy machine to reproduce a copy enlarged by 33 percent. Then, cut a piece of acid-free paper that measures 8½" × 5½". Since the Rosh Hashanah card pattern is an asymmetrical design, it has to be transferred following the same directions mentioned here for transferring Hebrew letters, but for the whole design, not just for the letters. First, transfer the pattern from the enlarged copy onto tracing paper. Next, go over every line of the design with a pencil on the side of the tracing paper where the letters appear forwards. Then turn that over, face down, onto the back left-hand side of the acid-free paper with the design showing through backwards and trace over every line with a sharp pencil.

To fold this thick paper into a card, it is necessary to score it. After you measure it carefully, draw a faint line down the exact center of the paper on what will be the inside of the card. Hold a metal straightedge down firmly at the line. Using a utility knife with a dull (used) blade, cut gently down the line without cutting through the paper. Do not use a straightedge that you use for measuring or drawing, since using it as a cutting edge will reduce its accuracy. The paper should now fold easily. Using a bone folder will help you achieve a clean and crisp fold. These tools are shaped like flat sticks that are made of bone or plastic. They can be purchased at well-stocked artist's supply stores or ones that specialize in book-art supplies. After the paper is folded over, you press the bone folder down along the fold line to smooth it out. You may want to make this score line before doing the cutout. If you make a mistake scoring before cutting, less effort will be wasted than if you had cut out the design first. Scoring can be tricky. You may cut completely through the paper the first few tries. It might be

a good idea to practice scoring on a scrap piece of the acid-free paper first. After the card is scored and cut out, you can attach a piece of colored paper to the back of the design on the inside of the card, or just slip it into the card without attaching it.

CUTTING THE DESIGN

When you begin cutting, start with a new blade. With thicker paper, you will find that you need to replace the blade more often. I cannot stress enough how important it is to cut with a sharp blade. It certainly helps for ease in cutting, but more important to the finished work, it makes all the difference in the way your cut lines will look. Cutting with a dull blade results in jagged and torn edges. I have seen lovely designs ruined by edges that looked as if someone had used their teeth to do the cutting. In addition to a sharp blade, the mat cutting board described in chapter 2 will make it easier to cut thicker paper. When investing in a mat cutting board, buy as large a size as you can afford. The board should be larger than your papercut. Otherwise, you will need to keep moving the papercut around on the board so that you are cutting on top of it. Also, if the board is smaller than the paper, resting your arm on it during cutting can put a deep crease in the paper where it touches the edge of the cutting board.

The #11 blade suggested in chapter 2 as an ideal blade for papercutting has a narrow and sharp point. This is very useful for cutting small and intricate spaces. There are blade sharpeners available on the market. They work similarly to an electric pencil sharpener, except that they sharpen blades. It may seem wasteful, but I prefer not to use them. Each time you use the blade sharpener, a little more of the narrowness of the blade is lost, making it harder to get into tiny spaces to cut.

It may help to practice cutting on scraps of the same paper as your papercut before starting your first cut on the acid-free paper. With practice, you will get the feel of how much pressure to apply to get a clean cut. Each person develops his or her own cutting technique, but there are rules for cutting sharp corners, whether they are negative or positive space. When you are cutting out a negative space that has two lines meeting in a corner or point, start cutting each line from the common point and cut outward. This technique will assure that you cut all the way through the paper at the common point, and the cut-

out piece will come out easily. When a pointed shape or corner is positive space, start the cut away from the corner and cut toward it. This will prevent the pointed piece from scrunching up.

Make it a habit to cut only on the drawn lines, and try not to cut beyond the end of a line. Following these rules will help to prevent an accidental cut into positive space. Also, while a straightedge and other tools may be helpful in drawing, I do not recommend using them as guides for cutting. It takes enough concentration to cut a straight line without trying to hold a straightedge stationary. If the straightedge should move while you cut, your knife will follow.

When you dispose of blades, do not throw them directly into the trash. As you replace them, stick a piece of masking tape over the sharp side of the used blade and throw it away. If they won't be in the way, you can make a little pile of used blades while you are working. At the end of each work session, wrap them all in a piece of masking tape so that the points are covered before throwing them away. Art supply stores may carry plastic containers with a narrow slit on the top for disposal of knife blades, as well as razor blades. As they become heavier, these containers make nice paperweights. When they are completely full, they can safely be thrown away.

Having a steady hand while cutting will help you to avoid making mistakes. However, a slip of the knife does not necessarily mean complete loss of a papercut. Sometimes it is possible to improvise by reshaping an image or finding that you can do without the piece you may have accidentally cut off, such as a leaf from a tree. It is possible to make repairs, although I would not recommend having more than a few repairs in a single papercut. Document repair tape can be used to make simple repairs where a cut was made but did not completely separate a piece from the whole papercut. This is a very thin see-through tape that must be burnished onto the paper to facilitate its sticking. Tear off a piece and place it on the back of your papercut over the cut area. Do not worry if the tape hangs over the edge of the paper. Rub the tape, using a hard object, such as the end of a pen, your fingernail, a bone folder, or a burnishing tool. Do this carefully so your hand does not slip and ruin another part of your papercut. The tape will be smooth and completely transparent when fully burnished. Turn the papercut over to the front side. Using your cutting knife, carefully trim away any tape that is showing. You may be able to see the cut line faintly after this repair, but the document repair tape will hold it together.

If you design a simple papercut, you can try using the tiny scissors described in chapter 2, rather than a knife. As with knife blades, scissors cut more easily and cleanly when they are sharp. If you have a pair of scissors that you intend to use for papercutting, do not use them to cut anything else. They will stay sharper that way.

When you have completed cutting your papercut, remember to sign and date it. Add © as well. This implies copyright protection.

SETTING UP A WORK SPACE

Before you start drawing out your design, set up a comfortable work area. Each step, from drawing and transferring your design to cutting it out, will be easier and more enjoyable when you have a comfortable place to work. When you work in one position for long periods of time, as may happen when you create a papercut, two areas of concern are back and eye strain.

Back strain can come from sitting in one position and bending over a table or desk for a long time. Adjustable drafting tables enable you to work on a slanted surface, requiring less bending, although it may not be necessary to invest in a drafting table. When you work at a flat table, you can relieve back pressure by altering your sitting position. Sitting on your knees on the chair allows you to lean over without putting pressure on your back because your weight is shifted to your knees. Of course, the chair should be cushioned for comfort. I found this to be a very comfortable position, allowing me to work for long periods of time, before I got a drafting table. In fact, there are chairs specially designed with this sitting position in mind and intended for people who sit for long periods of time.

Someone with a strong back may not be so concerned about his or her sitting position, but proper lighting is important for everyone. Eye strain can be caused by doing close-up, detailed work without proper lighting. Indirect sunlight is the best source of light for working without straining your eyes, but it is not always possible to work during the day or to have access to a window providing the proper sunlight to work comfortably. In this case, it is often better to rely upon two lighting sources, the regular room lighting and an additional light source, such as a swing-arm lamp that clamps to the edge of a desk or table. Cutting may require more light than drawing. Move the lamp closer to the work surface as needed. It is the combination of both of

these light sources, not just one or the other, that offers proper lighting. Using just the room light does not usually provide enough brightness. Using only the desk lamp in an otherwise dark room can result in eye strain caused by your eyes readjusting from light to dark every time you look away from your work.

CHAPTER 5

FRAMING YOUR WORK

When you frame your artwork, it is important to do so in such a way that will ensure its preservation. Whatever comes in direct contact with the papercut inside the frame should be acid-free like the paper itself, since the acidic content of anything touching the papercut will also adversely affect it. There are a number of ways to frame papercuts. Included here are a few suggestions that have proven successful. What follows describes what is inside the frame.

GLASS AND MAT BORDER

Starting at the top is the piece of glass. It should be cleaned carefully and thoroughly with glass cleaner and handled by the edges at all times after that. Be careful not to run your hand on the edge of the glass. Next is the mat, a board with a rectangular or square window surrounded by a two- to three-inch border of mat material. The dimensions of the window should measure a little larger than the papercut. For example, if your papercut design measures 10" × 12", the window should measure at least 10½" × 12½". If your design is circular, the mat window can be cut either in a circle or square. The diameter of a circular window should measure at least ½" larger than the diam-

eter of the design. A square window should measure, in length and width, at least ½" larger than the diameter of the circular design. For instance, if your papercut design is a 14" circle, the square window should measure 14½" × 14½". Using a double mat is another possibility. The window of the top mat is cut larger than the one underneath, usually ¼" on each side. It is the outside dimensions of the top mat that will determine the size of the frame.

The top mat is important, as it gives a nice finished look to your papercut and serves to keep the papercut from resting directly on the glass. Colored mat board can be used. Though not completely acid free, it is available with acid-free backing. White or off-white museum-quality board, which is 100 percent acid-free, can be used instead. For some, the acid-free backing of a colored mat board serves as enough protection for their work when the look of a colored border around the white papercut is preferred. A double mat gives you the opportunity to use two colors.

The papercut is attached to the back of the mat, with the front of the papercut showing through the window. Be sure to center the papercut properly when attaching it. This attachment is the reason you need that extra edge of paper around the papercut. Document-repair tape, which was described for use in repairing mistakes, or an acid-free hinging tape is used to attach the papercut. The hinging tape is a gummed paper product that is moistened to stick to surfaces. It is heavier than the document-repair tape and is preferable when using thick papers. Use a slightly damp sponge to moisten it since saliva has an acidic content. Tape the papercut to the back of the mat at the top only.

THE BACKGROUND

Behind the papercut is the background paper. There are brands of mat board that have matching paper, which can be used for the background. For an unusual but striking effect, you might want to try a marbleized paper behind your papercut. The same store where you purchased your white paper for the papercut will also have a selection of colored papers to choose from.

It is especially nice to have a space between the papercut and the background paper to create a shadow. To achieve this effect, one of two things can be done. One option is to use a piece of glass or acrylic

cut to the same size as the frame and place it between the papercut and the background paper. Acrylic is a hard plastic material that looks like glass. Furthermore, acrylic is unbreakable and much lighter in weight than glass. For this reason, using acrylic of $\frac{1}{8}$ inch thickness is suggested, especially for larger pieces. (In fact, acrylic can be used in place of glass for the top also.) Acrylic is an inert substance. This means that none of its properties can harm the papercut, nor can any acidic material that might be on the other side of the acrylic pass through it to harm the papercut. When purchased, acrylic is covered on both sides by paper, which is peeled off. Peel off the paper and clean the acrylic just prior to putting it in the frame. The acrylic should be cleaned with spray plastic cleaner or warm soapy water (made from liquid soap), and a very soft nonabrasive cloth. Handle the acrylic at the edges after it is cleaned. *Never* use glass cleaner on acrylic. (If you have used acrylic in place of glass at the top, the acrylic can be cleaned with Pledge furniture polish. However, do not use this polish on any acrylic surface that will come in direct contact with the paper.)

The other option is to use foam-core, which is an $\frac{1}{8}$" or $\frac{3}{16}$" thick board with a stiff foam center sandwiched between two pieces of paper. To use foam-core, cut a piece the size of the frame. Then cut a window into the foam-core that is larger than the window of the top mat. This, like the acrylic, is placed between the papercut and the background paper. Regular foam-core is about 98 percent acid-free with a pH level of 6.5–7.0. Acid-free foam-core is available with a pH level of 7.5–8.5. By separating the papercut from the background paper in this manner it is not necessary to use a background paper that is acid free because any acidic content cannot touch the papercut.

It is also possible to decorate your papercut with watercolor and use the same acid-free white paper for the background. Practice painting with watercolors before using them to decorate your papercut. Watercolor paints can be tricky to use. Practice on the same type of paper as the papercut. Experiment with the paints to see how much water to use to achieve the desired consistency and brightness, as well as to see how much the paint will spread. Use good-quality brushes so that hairs from the brush won't fall out and stick to the wet paint on your papercut. Otherwise, you will need to spend time removing brush hairs from your beautiful artwork. A white mat border may be preferred for a brightly painted papercut.

Behind the background paper is a piece of cardboard or mat board cut to fit snugly inside the frame. Again, the cardboard or mat

board does not have to be acid-free since it will not be touching the papercut. If you have not separated the papercut from the background paper with acrylic or foam-core, use a piece of mat board with an acid-free backing. Place it in the frame with the backing side in. A snug fit in the frame is important to keep the work flat and to prevent it from moving or buckling inside the frame.

THE FRAME

The way it is all held together will depend on whether you use a metal or a wood frame. A metal frame, in either kit form or one that is custom cut, includes all the hardware you will need as well as instructions on assembly. Metal frame kits are sold with two sides of the same length per package. It is necessary to purchase two packages to make one frame. One package will be the height of the frame, the other the width. The hardware includes L-shaped pieces and tiny screws that connect the sides of the frame together and metal strips that will hold everything snugly inside the frame. They are easily assembled, using a screwdriver. When using a wood frame you can use thin brads (extra-thin nails) to hold everything inside the frame. Use a small pliers to grasp the end of the brad and push it in about halfway into the inner sides of the frame. There should be several brads along each side, one near each corner and three or more brads between those. How many will depend on the size of the frame. The protruding part of the brad is then pressed down onto the cardboard backing. To give the back a neater look, use pressure-sensitive frame sealing tape around the back edge to completely seal the work inside the frame. Papercuts generally look best in simple, rather than ornate frames, which tend to distract from the intricacy of a papercut.

As mentioned, the size of the frame is determined by the outside dimensions of the top mat border. Ready-made frames come in standard sizes: 5" × 7", 8" × 10", 11" × 14", 12" × 16", 14" × 18", 16" × 20", 18" × 24", and larger. These can be less expensive than having a frame custom-made. When deciding on the size of your papercut, which will determine the size of the mat border, you may want to keep this in mind. Most artist's supply stores have frame selections, along with custom framing services.

When you shop for frames, there is one other determining factor. When framing your papercut in the way described, the depth of

the frame will need to be at least ½" thick to hold everything: two pieces of glass or acrylic, the papercut and background paper, mat and cardboard backing. Both metal and wood frames are made with varying degrees of depth. Pre-cut metal frames sold in kits do not have the depth needed. Nor do they come in the wide variety of colors available with custom framers. Stores with large frame selections should have standard-size wood frames with the necessary depth.

Some people may enjoy framing their own work, while others will want a professional to do it. Before you hand your work over to professional framers, find out if they have framed papercuts before. If not, be sure they understand exactly what you want. Even if you frame your own work, it will probably be easiest and will look best if you have the window for your mat cut by a professional. It is possible to order a custom-made frame without having the store frame your papercut. Simply order the necessary mat and glass or acrylic along with the frame. When your frame is ready, you can take it all home and put it together yourself.

When framing at home, I am always tempted to work on the floor so that I can spread everything out. However, it is best to work at a clean table, where carpet hairs and dust are less likely to get caught inside the frame. As you add each part, continue to be sure that no dust particles are present. Keep your eraser brush handy for this, or try using a blow dryer set at the lowest setting. Never blow away dust particles with your mouth. Move away from the papercut and mat when cleaning your glass and acrylic. You don't want any of the cleaning products to get sprayed on your work. Be sure the glass and acrylic are completely dry before you add them to the frame.

Besides dust particles, another concern when framing is fingerprints on your glass or acrylic. You will find thin white cotton gloves at photographic supply stores that you can wear when you are framing, so you won't have to be so careful handling the glass or acrylic. Of course you still have to be careful not to cut yourself on the glass, but you won't have to worry about fingerprints.

Before you seal the frame together with brads or metal strips, check the front carefully for any stray dust particles or hair that may have escaped detection earlier. Occasionally, you will get the whole thing together and notice a piece of dust or hair and will have to take it apart again. Remember, doing your own framing takes time and patience, just as cutting your papercut did.

One of the best parts of creating an original papercut is the time

when you are ready to hang it. Do not hesitate to hang it in a place where it will be seen by everyone who enters your home. A *mizrah* will be hung on an east wall, but other than that rule, papercuts look wonderful anywhere. Do not hang your papercut where it will be exposed to direct sunlight, which can cause aging and fading despite the use of archival materials.

APPENDIX: MUSEUMS

Reading about papercuts and seeing pictures of them is one thing, but if the art form intrigues you, particularly if you've created one of your own, seeing them live and up close can be especially exciting. With the renewed interest in folk art over the past several decades, exhibitions that include papercuts are likely to pass your way at one time or another.

The following list of museums is separated into three sections: Jewish Museums in North America, Jewish Museums in Europe and Israel, and secular Folk Art Museums in the United States. Every museum listed includes papercuts in their collection, but very few, unfortunately, have them on permanent display. Most often it is the fragile nature of some of these older papercuts that prevents them from being on permanent display. When you see old papercuts in museums, it is generally under soft lighting since harsh light will speed up the aging process. Of the papercuts not on permanent display, many are included in traveling exhibitions from time to time.

Several of the museums listed here have allowed their papercuts to be included in this book. These are noted below. In addition, if a museum owns a particularly unusual item or if it does have papercuts on permanent display, that is also noted. This is not a complete listing of Jewish or secular folk art museums. It is a listing of the ones that responded to my survey.

JEWISH MUSEUMS IN NORTH AMERICA

Beth Tzedec Museum
1700 Bathurst Street
Toronto, Ontario M5Z 2N7
CANADA

The Jewish Museum
1109 Fifth Avenue
New York, New York 10128

Skirball Cultural Center
2701 North Sepulveda Blvd.
Los Angeles, California 90049
(Scheduled opening: Fall 1995)
The papercuts shown on pages
 4, 11, and 13 are from the
Skirball Museum collection.

Spertus Museum
618 South Michigan Avenue
Chicago, Illinois 60605

JEWISH MUSEUMS IN EUROPE AND ISRAEL

Musee d'Art Juif de Paris
(Museum of Jewish Art)
42, Rue des Saules
75018 Paris
FRANCE
The illustration on page 5
 comes from this museum.

Jüdisches Museum der Stadt
 Frankfurt am Main
Untermainkai 14/15
6000 Frankfurt am Main
GERMANY
Papercut *mizrah* on perma-
 nent display in a showcase
 explaining Shabbat.

Jewish Historical Museum
Jonas Daniel Mejerplein 2–4
1001 Amsterdam
THE NETHERLANDS
A very fine papercut *megillat*
 Esther is on permanent display.

Jüdisches Museum der Schweiz
Kornhausgasse 8
Basel, 4051
SWITZERLAND
The illustration on page 8
 comes from this museum.

Haifa Museum of Music and
 Ethnology
26 Shabbetai Levy Street
31451 Haifa
ISRAEL
They believe they own the
 world's largest papercut.

The Israel Museum
Post Office Box 71117
91710 Jerusalem
ISRAEL
There may be a few papercuts
 on permanent display, but
 most are in storage. The
 papercuts shown on
 pages 7 and 9 come from this
 museum.

Wolfson Museum
58 King George Street
Hechal Shlomo
91073 Jerusalem
ISRAEL
Extensive collection of paper-
 cuts, some of which are on
 permanent display.

SECULAR FOLK ART MUSEUMS IN THE UNITED STATES

Mingei International Museum
Post Office Box 553
La Jolla, California 92038
Papercuts from China, Poland, and Mexico. Some may be on display.

Craft and Folk Art Museum
6067 Wilshire Boulevard
Los Angeles, California 90036
Papercuts from Mexico, China, and Japan. Most are in storage unless they are used to augment another exhibition.

San Francisco Craft & Folk Art Museum
Building A
Fort Mason
San Francisco, California 94123

Museum of International Folk Art
Post Office Box 2087
Santa Fe, New Mexico 87504-2087
Their collection includes 200 Polish papercuts and 100 Mexican papercuts, which are contained within the Girard collection.

Museum of American Folk Art
2 Lincoln Square, between 65th and 66th Streets on Columbus Avenue
New York, New York 10023

NOTES

INTRODUCTION

1. Michael Kaniel, *A Guide to Jewish Art* (New York: Philosophical Library, 1989), 11. The introduction on pages 11–15 provides a very thorough discussion of this entire issue.

CHAPTER 1

1. Nancy Zeng Berliner, *Chinese Folk Art: The Small Skills of Carving Insects* (Boston: Little, Brown, & Co., 1986), 98.

2. Berliner, *Chinese Folk Art,* 98. All other information relating to papercutting in China was obtained from the chapter on papercutting, pp. 97–123 in this book.

3. Vance Studley, *The Art and Craft of Handmade Paper* (New York: Van Nostrand Reinhold Company, 1977), 18.

4. Giza Frankel, *The Art of the Jewish Papercut* (Tel Aviv: Masada, 1983), 9. (Hebrew)

5. Giza Frankel, "Papercuts Throughout the World and in Jewish Tradition" in *The Paper-Cut Past and Present* (Haifa: Ethnological Museum and Folklore Archives,1976), 26.

6. Esther Juhasz, "Papercuts" in *Sephardic Jews in the Ottoman Empire*, ed. Esther Juhasz (Jerusalem: Israel Museum, 1990), 239.

7. Otto Kurz "Libri cum characteribus ex nulla materia compositis," *Israel Oriental Studies 2* (Tel Aviv University, 1972), 240.

8. Mordecai Narkiss, "Hituv-neyar Yehudi." *'Ofakim*, 1944, 29.

9. Narkiss, 30.

10. Juhasz, "Papercuts." Further information on Jews in the Ottoman Empire and papercuts from that region was obtained from this chapter in the book, *Sephardic Jews in the Ottoman Empire*, 239–253.

11. Frankel, "Papercuts Throughout the World," 24.

12. *Encyclopaedia Judaica*, 1971, "Papercuts," by Giza Frankel.

13. Information for the description of the *mizrah*, as well as the other types of papercuts to follow, come from the three previously cited sources by Giza Frankel, except where otherwise noted.

14. Juhasz, "Papercuts," 244–245.

15. Frankel, "Papercuts Throughout the World," 24.

16. Juhasz, "Papercuts," 244.

17. Michael Strassfeld, *The Jewish Holidays: A Guide and Commentary* (New York: Harper & Row, 1985), 129.

18. Joy Ungerleider-Mayerson, *Jewish Folk Art: From Biblical Days to Modern Times* (New York: Summit Books, 1986), 49–51.

19. Norman L. Kleeblatt, *The Jewish Heritage in American Folk Art* (New York: Universe Books, 1984), 24.

20. Ibid., 57.

21. Ibid., 115.

22. Ibid., 101.

BIBLIOGRAPHY

Berliner, Nancy Zeng. "Papercuts." *Chinese Folk Art: the Small Skills of Carving Insects,* 97–123. Boston: Little, Brown, & Co., 1986.

Frankel, Giza. *The Art of the Jewish Papercut.* Tel Aviv: Masada, 1983. (Hebrew).

——. "Papercuts Throughout the World and in Jewish Tradition." *The Paper-Cut: Past and Present,* 24–26. Haifa: Ethnological Museum and Folklore Archives, 1976.

Juhasz, Esther. "Papercuts." *Sephardi Jews in the Ottoman Empire,* ed. by Esther Juhasz, 239–53. Jerusalem: Israel Museum, 1990.

Kaniel, Michael. "Introduction—Judaism and Art." *A Guide to Jewish Art,* 11–15. New York: Philosophical Library, 1989.

Kanof, Abram. "Introduction: Ceremony and Art in Jewish Life" and "Judaism and Art." *Jewish Ceremonial Art and Religious Observance,* 9–27. New York: Harry N. Abrams, Inc., 1969.

Kleeblatt, Norman L., and Wertkin, Gerald C. *The Jewish Heritage in American Folk Art.* New York: Universe Books, 1984.

Ungerleider-Mayerson, Joy. *Jewish Folk Art: From Biblical Days to Modern Times.* New York: Summit Books, 1986.

INDEX

About the Author

Amy Goldenberg, a folk artist living in Los Angeles, California, has been creating Jewish papercuts for over a decade. A former religious-school teacher, she earned an art degree from California State University, Northridge.